dedications

SUSAN TUTTLE

I dedicate this book to my loving family, Howie, Elijah and Rose. I feel like my best self when I am with you. You are my greatest gifts.

For Grace, who helps to keep me on the path.

CHRISTY HYDECK

With immense gratitude and a humble heart, I dedicate this book to each of you who have touched my life and graced it with love and kindness. Whether it was through a smile in passing, words of encouragement, enthusiastic support for my endeavors or the love, friendship and acceptance that was so freely given to me—you have inspired me to live my best and most creative life.

And, to Carl, who selflessly gave me his all during the creation of this book and only asked that I use the word *penumbra* somewhere within its pages. I hope I have just succeeded.

CONTENTS

PHOTOS BY SUSAN TUTTLE

PHOTO CRAFT

Creative Mixed-Media
AND DIGITAL APPROACHES TO
TRANSFORMING YOUR PHOTOGRAPHS

SUSAN TUTTLE AND CHRISTY HYDECK

NORTH LIGHT BOOKS

CINCINNATI, OHIO
WWW.CREATEMIXEDMEDIA.COM

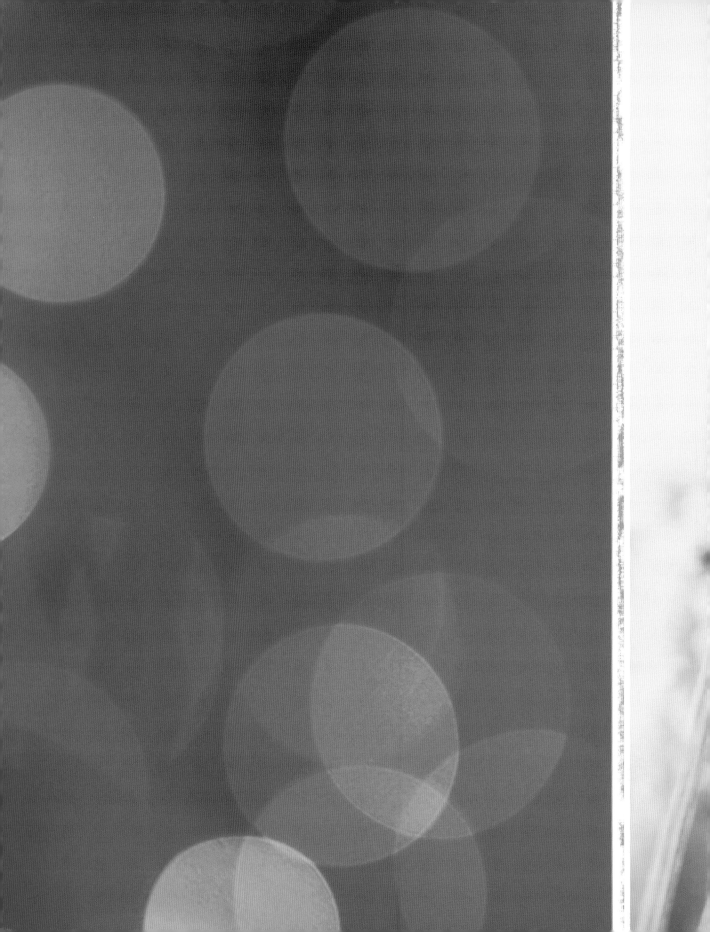

PHOTOS BY SUSAN TUTTLE

TO OUR READERS

Hello, you!

Photography changed my life. I'm madly convinced it can change yours, too.

I don't typically start off letters with such profound declarations, but in this case I felt it was necessary. Grab a cup of (insert-your-favorite-beverage-here) and I'll tell you a bit about this life-changing stuff. Though we just met, I feel as if we're practically old friends anyway and I'm just so very excited to share this with you.

You see, somewhere along the way I stopped snapping pictures and began seeing things. Like, really, truly seeing things. It was kind of like being reborn, but in a far less messy or dramatic fashion. Keep in mind, there was no one magic moment when I knew this, no symphony playing some amazing score to accompany the realization, and certainly no fireworks exploded over my head. Although, how cool would that have been?

Anyway, I digress.

What began as noticing these seemingly small glimpses of extraordinary beauty turned into an all-out scavenger hunt. Why wait for the loveliness to appear in front of me? I began seeking it. I began documenting it with my camera. I began to appreciate the things I already had and stopped wanting the things I didn't have. Well, mostly. Truth is, I didn't stop wanting, but I realized happiness wasn't in those things I thought would bring me some misguided sense of fulfillment. I already had all I needed.

Oh—friends! It's an absolutely amazing world out there! And I'm not just talking about exotic trips to far-off lands. It's beyond amazing in your own backyard; it really, really is! You just have to look a little. When my bipolar brain veers off track and I begin to forget that, my photos are there to remind me.

I'm coming dangerously close to a weepy-eyed Oprah moment here, so before we each start passing the tissues around, let me just say that once I allowed photography to open my eyes, my perceptions changed and with that, my emotions changed. Before I could even put what was happening to me together, photography had already helped make this bipolar girl a bit more stable. As the sayings go, "Thoughts become things," and "We are what we think," and all that jazz we kind of already know but too often dismiss.

I'm pretty convinced my camera has superpowers. It staves off depression when it shows me how raindrops on a spider web glisten like diamonds, it wards off my evil hermit-like tendencies when I am out and about, and it gives me a sense of purpose when I have forgotten my place in this world. As an artist, photography has improved my technical skills tenfold. There are so many mini-art lessons within each photo session: color theory, composition, design, light . . . the list goes on and on. As a photographer, art has given me a more creative vision, a sense of uniqueness and the confidence to try things that others may not. And for me, photography and art are a creative match made in heaven. It is my sincere hope that this book will help you see that too. As the Lensbaby slogan goes, "See in a new way."

I'll tell you a little secret: It doesn't really matter what kind of camera you have; whether you work it manually or set it to auto mode, you have the ability to create great images. I'll show you some fun and unique ways to incorporate your photos into your mixed-media art. Photographers, this is a totally great chance to offer some unique and artistic products to your clients or to just let loose and get your hands dirty. Susan guides you through a ton of amazing ways to enhance your photographs digitally. Through her easy-to-follow guidance, these techniques can elevate an average photograph to extraordinary.

As Michael Toms said, "You have a creative contribution to make. Your life, and mine, will be better if you do."

And I for one—couldn't be happier about it.

Warmly,

Christy

Hello, hello.

For my ninth birthday I received a Kodak 110 camera with attachable flash packs—remember those? As I looked through the viewfinder, I began to feel the stirrings of my love for photography and attempted to capture aspects of my world that I could feel resonating somewhere within me. I'd photograph flowers, hot air balloons, animals and friends and family. I was disappointed, however, when my printed film came back looking less than stellar, bearing little or no likeness to what I had felt and seen through the little plastic square of my camera. Perhaps you have had a similar experience. The limitations of the equipment eventually put a hold on my love of taking photos, but my passion still remained, dormant, waiting and resurfacing full throttle in 2003 when I received my first digital camera after my son was born.

Due to technological advances in digital photography and software, creating stunning photographs has never been easier than it is in this day and age. Even today's most basic cameras can produce stunning artistic imagery. Within the pages of this book, Christy and I aim to show you that creative photography is a result of following your artistic instincts and creative vision combined with the use of technology, however basic. We will guide you through both digital (via Photoshop Elements) and mixed-media photo manipulation techniques. Included are stepped-out, technique-based tutorials, inspirational tips, explorations of iPhoneography, unique photo shoot ideas, skill-enhancing assignments and stellar contributions from other artists. Many of the mixed-media and digital projects are presented as mirrors of each other, meaning, they demonstrate how similar results can be achieved through either medium.

Once you manipulate a photograph via one of my digital projects, you might consider taking that altered photo and using it as imagery for one of Christy's mixed-media projects. The projects within this book have a lot of crossover potential, so keep that in mind as you explore its pages.

I created my digital projects using Adobe Photoshop® Elements® 9.0, which is available for both Macs and PCs. These projects are compatible with both earlier and subsequent versions of Photoshop Elements. Readers who are using Adobe Photoshop, including Photoshop CS, will also find the projects to be compatible with their software (though the instructions may vary).

Please note that the iPhoneography apps mentioned throughout the book may or may not be compatible with your particular edition of the iPhone/iPod Touch. You can find similar or more-current versions of these apps via an app called AppAdvice (search the Photography category).

You will also find a helpful reference section of essential digital tools and techniques in the front of the book.

There are many ways to approach an artistic task in Photoshop. As you explore the digital activities in this book, you will begin to discover your own ways of carrying out the techniques and take pleasure in adding personal, artistic touches that reflect your unique, creative voice.

It is my hope that you will find artistic tools within the pages of this book that will enhance your creative life and bring you joy.

Peace.

Susan

CHRISTY'S ESSENTIAL MIXED-MEDIA TOOLKIT

Between the pages of this labor of love, I will guide you through a variety of fun mixed-media and DIY techniques. Each of these tutorials uses some of my favorite tools and supplies. The list below gives you an overview of the goodies I use most and some of my most common uses for them.

I cannot stress enough the importance of safety. Please be sure to read and follow the manufacturers' labels and warnings before using any kind of supply. Not all products are nontoxic, and it is important to know which materials have the potential for hazardous effects, in addition to knowing the proper use recommended by the manufacturer.

Substrates

Wood Board: Most home improvement stores, at no charge, will cut pieces of wood that you purchase into the sizes you desire. It is an economical and customizable way to use solid material. Just remind them to take into consideration the thickness of the saw blade if you need the measurement to be an exact size. I prefer stain-grade wood as a general rule of thumb, but if you don't mind a bit of prep work, you can save a few bucks by purchasing wood that isn't prepared.

Cradled Wood Board: Sold through many art supply companies, cradled wood panels are by far my favorite surface to work on. Sturdy, smooth and ready to hang, these substrates can handle just about any medium.

Canvas: This timeless surface comes in just about any size, shape or texture you desire. For projects with heavy mediums, I prefer canvas boards. For mixed-media paintings without the bulk, I like gallery-wrapped canvases for a polished no-frame-needed finish.

Acrylic Mediums

Gel Medium: It's an adhesive! It's a paint extender! It's a texture aid! It's a super medium! It really is! If you work with mixed media, this is on the short list of must-haves. Incredibly versatile, you'll find yourself reaching for it often. It can be used as an adhesive, can change the consistency and transparency of acrylic paint, can extend working time, and it can transfer images. Heavy gels hold their peaks and work wonderfully when you want texture. Mix in glass beads, mica flakes, glitter and more for interesting transparent glazes. The possibilities are endless.

Acrylic Glazing Liquid: I can't think of a piece I have made within the last six years in which I haven't used this stuff. A thinner consistency than gel medium, glazing liquid mixed with acrylic paints makes the paints more transparent and extends working time. You can create beautiful glazes or blend and seal watercolor pencils, along with a host of other uses.

Gesso: The ultimate primer, gesso used as a base coat gives almost any surface a bit of tooth for the paint to stick to. Colors applied over it appear more vibrant. Scraping white gesso over images can produce a ghostly effect, and using it in thick layers can provide a textured surface. Clear gesso is a go-to supply for me. Brushed over a work in progress, it provides a workable surface on which to sketch.

Crackle Medium: There are many varieties on the market and although all work a bit differently, the end effect remains the same: an aged, crackled appearance.

Modeling Paste: Often used to create a heavily textured surface, this thick paste can be tinted while wet or painted over once it has dried. The paste retains the shapes, patterns and peaks you create while it's wet.

Acrylic Paints: Acrylics are fast-drying and come in a variety of consistencies. Whether mixed with other acrylic mediums, diluted with water or used as is, they are an indispensable supply in my studio.

Miscellaneous

Tim Holtz Adirondack Alcohol Inks: These vibrant acid-free inks make adding color to slick surfaces like glass or metal a breeze. The transparent formula is perfect when it comes to tinting photographs I have transferred onto metal.

Beeswax: Did you know that honeybees fly approximately 150,000 miles (the equivalent of six rotations around the earth) to produce one pound of wax? Amazing, isn't it? In this book we will discover the dreamy possibilities of wax combined with photography. While you can use the big blocks of wax if you like, I prefer the pellets because they melt faster.

Acrylic Inks: These are thin, watery pigment-based inks that are vibrant and can be blended with acrylic paints if desired. They make for wonderful washes of color, are lovely to use with a writing tool, and though we don't do it here, they can be used to tint photographs as well.

Sketch Ink/Liquid Pencil: Pam Carriker's signature line of Liquid Pencil Sketching Ink is fast becoming one of my favorite products. A graphite-based ink that comes in squeezable bottles, it can be used in washes, on stamps, as a paint and even burnished to a sheen just like a pencil. The line includes both permanent and rewettable formulas.

PanPastels: These come in a myriad of vibrant and intense colors. The pastels, which come in convenient round pans, are rich, creamy and low in dust.

Printer Supplies + Paper:

Printers: Almost all of my projects can be carried out with a standard ink-jet printer. As the settings and controls vary per printer, you'll need to consult your user manual if questions arise. I find that gel transfers work better on images printed with a toner-based ink like a laser printer.

Ink-Jet Papers: There are as many types of ink-jet papers as there are moods! I use and prefer high-quality fine-art papers. These are typically archival and often provide a sturdier base for working with wet mediums. I am partial to 100 percent cotton photo rag paper and watercolor paper made specifically for ink-jet printers.

Professional Prints: As much as I love my printer, you can't beat the quality of a professional lab. I also find that it can (surprisingly) be more economical.

➤ MY BASIC TOOL KIT

Here's a list of the versatile tools and accessories I reach for most often. Their uses are vast, as you will discover while exploring the projects.

∞ *Baby wipes/paper towels*

∞ *Brayer*

∞ *Paintbrushes*

∞ *Unconventional painting tools (sponges, bubble wrap, credit cards, assorted lids—if it leaves a mark, it is fair game!)*

∞ *Sharp awl*

∞ *Stencils*

∞ *Stamps*

∞ *Paint scraper*

∞ *Craft knife*

∞ *Nonstick scissors*

∞ *Nonstick tweezers*

∞ *Charcoal*

∞ *Pencil*

∞ *Glue stick*

∞ *Ephemera and patterned papers*

FOR A COMPLETE AND ALWAYS EVOLVING LIST OF THE PRODUCTS, BRANDS AND MATERIALS I USE MOST OFTEN, PLEASE VISIT THE FOLLOWING PAGES OF MY WEBSITE:
PHOTOGRAPHY GEAR: ALWAYSCHRYSTI.COM/PHOTOGRAPHY-GEAR
MIXED MEDIA SUPPLIES: ALWAYSCHRYSTI.COM/ART-SUPPLIES
IPHONEOGRAPHY GEAR: ALWAYSCHRYSTI.COM/IPHONOGRAPHY-GEAR

SUSAN'S ESSENTIAL DIGITAL TOOLS + TECHNIQUES

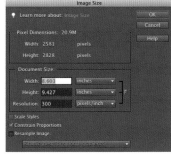

In this section, I'll introduce you to the various techniques and tools you will need to complete the digital projects in the book. Please note that this is not a comprehensive list of all actions that can be performed with Photoshop Elements (PSE). These techniques are specific to the projects contained within this book. I recommend reading through this section before you begin any of the digital projects. Experiment with the various tools and techniques so you are familiar with them. Use this section again, for reference, as you work through each of the digital projects. When you become familiar with PSE, you will discover that there is more than one way to reach the same end result. Keep this in mind as you explore the digital techniques in this book.

BEFORE YOU BEGIN
You should be able to perform the following basic computer functions before you attempt the digital techniques and projects in this book: install and open the PSE application; use a mouse or graphics tablet; open a file; use menus and toolbars; operate a digital camera; import photos to your computer and retrieve them; operate a scanner.

Materials you will need before you can get started include: a computer; PSE (preferably version 9.0 or higher—trial versions are available online at www. adobe.com); digital camera; scanner; graphics tablet (optional, but preferred).

Setup
WORKING FILE
For the digital projects, you will often be working with multiple files at once. However, there will be one primary file to which you'll add imagery and make alterations. I will refer to this main file as your "working file." The working file will be either a duplicate of a photo or a new blank file.

CREATING A DUPLICATE FILE
Going to File>Duplicate will make an exact copy of a file you have opened. If you are starting with a photo that will be your working file, it is a good idea to make a duplicate of it first so you preserve the original.

FIGURE 1

IF YOU HAVE A LOW-RESOLUTION IMAGE, YOU CANNOT MAKE IT A HIGH-RES IMAGE BY MERELY INCREASING ITS DPI. TO CHECK THE IMAGE SIZE OF YOUR PHOTO GO TO IMAGE>RESIZE>IMAGE SIZE IN THE DROP-DOWN MENU.

CREATING A NEW BLANK FILE
When you want to create a new file with a transparent or solid-colored background, go to File>New>Blank File.

RESOLUTION
If you plan on printing your artwork, make sure the images you use are high resolution— at least 300 dpi (72 dpi is intended for posting to the Web). This will allow you to print high-quality artwork. If a digital photo you take is 72 dpi in a very large size (see Fig. 1), this is still high quality. But you should change the resolution of the image in Photoshop Elements to 300 dpi before working with it. To ensure high-resolution photos, set your camera and scanner to a high quality.

When setting up a New Blank File for printing purposes, make sure your file is at least 8" (20cm) wide and set its dpi resolution to 300. For the background, you can choose either white or transparent, depending on your needs.

SAVING FILES
When you want to save your working files, save them as a Photoshop (.psd) file. Doing so will preserve all layers for future manipulation. When your work is complete and you no longer need to save your layers for future manipulation, save the file as a JPEG (.jpg) or TIFF (.tif) file. If you plan on printing your artwork, make sure to save your image files at their highest quality. Also be sure to save files frequently as you work.

Selecting and Moving

DESELECTING

You can easily deselect any selection by going to Select>Deselect.

SELECTING AND MOVING WITH THE MOVE TOOL

The Move Tool, located at the top of the Tools Palette (see Fig. 2), will be one of the most used. Click on this tool prior to selecting and moving layers, as well as resizing and rotating. You can also use this tool to move one file of imagery to another.

SELECTING AREAS WITH THE LASSO TOOL

The Lasso Tool (see Fig. 3) allows you to make different types of selections. The basic Lasso Tool allows you to make a free-form selection. If you need more control when making your selection, I recommend using one of the other Lasso tools.

THE MAGNETIC LASSO TOOL

This tool works well when selecting objects with fine details, especially if the object contrasts with the background. Trace around the object in its entirety. You must end up exactly where you started in order to select it (you'll see a small transparent circle). If you miss a part, just press the Shift key and trace around the area that you want to add to the existing selection. Using the Move Tool, you can then click and drag the selection.

Use the Polygonal Lasso Tool when selecting areas with straight lines and angles.

SELECTING COLORS

To choose a paint color (to apply with tools such as the Brush Tool, Pencil Tool and Paint Bucket Tool), click on the Set Foreground Color box at the bottom of the Tools palette (see Fig. 4). A box will open, allowing you to choose from a broad range of hues. To choose a background color, click on the box behind the foreground color box.

WORKING WITH LAYERS

Layers in PSE are like the layers of paint and paper you build up as you create a mixed-media collage: some of the new layers completely cover what is below, while others allow lower layers to show through. In PSE, any new layer you add will cover

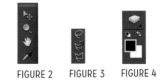

FIGURE 2 FIGURE 3 FIGURE 4

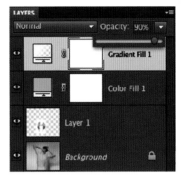

FIGURE 5

the layers below. You can reveal the layers beneath by using the Eraser Tool to reduce the Opacity of layers or by applying Blending Modes.

LAYERS PALETTE

The Layers Palette (see Fig. 5) shows each new layer you create; essentially they are stacked one on top of the other. These layers can be manipulated in a variety of ways, as you will see. You can turn layers on and off while you work—just click on the eye icon to the left of a layer in the Layers Palette and experiment until you find just the right look. You can delete a layer by selecting it in the Layers Palette and then clicking the trash can icon at the top of the Layers Palette.

CREATING A NEW LAYER

Whenever you add an image to your piece, e.g., dragging a new photo into your working file, the program automatically puts it on its own new layer. You can also create a new layer manually by going to **Layer>New>Layer**, which is helpful when you are adding brushstrokes.

ARRANGING LAYERS

There are two ways to arrange layers, which refers to moving a layer forward or backward in a file: (1) select the layer in the working file and go to **Layer>Arrange**, or (2) click the layer in the Layers Palette and drag it up to move it forward or down to move it back.

MERGING LAYERS

To organize and simplify working files, you can combine multiple layers into one layer. (Just be sure you will not want to manipulate the individual layers later on.) To do this, select the layers you want to merge in your Layers Palette by clicking on them while holding down the Command key (the Ctrl key on a PC). They will be highlighted once you click on them. Release the Command key when you have finished selecting the layers. Then go to **Layer>Merge Visible** (see Fig. 6) to merge them. Keep in mind that once layers are merged, they cannot be changed, only added to. Flattening an image (**Layer>Flatten Image**) merges all layers, giving you the opportunity to discard any hidden layers (layers you have turned off with the eye icon), and also converts transparent areas to white.

CREATING A CLIPPING MASK

The Clipping Mask feature allows you to mold a layer to the shape of another layer. For example, the storyboard project in this book utilizes a template with several photo frames for your images. The openings for the photos appear as colored squares, which are the photo masks. Essentially you "clip" your photo to the mask to get it to appear as if it is inside the frame (**Layer>Create Clipping Mask**). You can find more detailed instructions on the Clipping Mask feature in the storyboard project (see Chapter 6).

Making Adjustments

You can find most of the menus for making adjustments under the Enhance menu (see Fig. 7). I recommend using adjustment layers when possible (**Layer>New Adjustment Layer**), which are essentially duplicates of the base image. They allow you to make a variety of adjustments to your piece while keeping your original layer intact. This way, you can change or remove the adjustments later. You can also adjust the Blending Mode and Opacity of an adjustment layer.

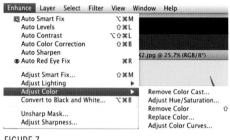

FIGURE 6

FIGURE 7

BRIGHTNESS/CONTRAST

Enhance>Adjust Lighting>Brightness/Contrast or **Layer>New Adjustment Layer>Brightness/Contrast**: This adjustment allows you to easily manipulate the tonal range of your imagery (see Fig. 8). Brightness refers to the lightness or darkness of an image, which affects color intensity. Contrast is the difference in brightness between the light and dark components of an image. In low-contrast images, there is little difference between the brightness of the light and dark areas. In high-contrast images, there is much difference between the brightness of the light and dark areas.

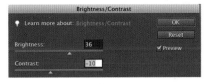

FIGURE 8

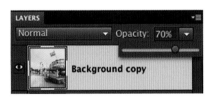

FIGURE 9

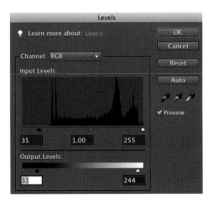

FIGURE 10

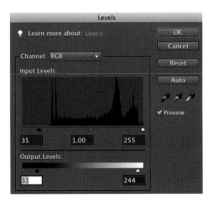

FIGURE 11

COLOR CURVES

Enhance>Adjust Color>Adjust Color Curves:
Use this command to adjust the tonal range of your imagery. You can adjust up to fourteen different points of an image's tonal range, from shadows to highlights, giving you more control than you get when using the Brightness/Contrast menu.

HUE/SATURATION

Enhance>Adjust Color>Adjust Hue/Saturation or
Layer>New Adjustment Layer>Hue/Saturation:
This command lets you manipulate the hue, saturation and lightness of either a specific color or all colors at once. You can manipulate individual colors by selecting them in the Edit drop-down menu. Check the Colorize box (see Fig. 9) to change an image to shades of just one color.

REMOVE COLOR

Enhance>Adjust Color>Remove Color: This feature allows you to desaturate the color in your photo by either reducing it or removing the color entirely.

OPACITY

You can adjust the opacity level of a layer by clicking on the layer in the Layers Palette and moving the Opacity slider (see Fig. 10) located at the top of the Layers Palette. You can also adjust the Opacity of various tools in their respective toolbars. Just move the slider to the left to increase transparency.

LEVELS

Enhance>Adjust Lighting>Levels
Layer>New Adjustment Layer>Levels: This feature allows for adjustment of color and tone. Within the format of a histogram, you can manipulate shadow values with the black point sliders, manipulate highlight values with the white point sliders and adjust middle tones with the gray point sliders (see Fig. 11). You can manipulate red, green and blue (R, G, B) channels as a whole or adjust each color individually.

Blending Modes

Blending modes control how pixels in an image are affected by a painting or editing tool. It's helpful to think in terms of the following colors when visualizing a blending mode's effect:

- ∞ The base color is the original color in the image.
- ∞ The blend color is the color applied by the painting or editing tool.
- ∞ The result color is the color resulting from the blend.

The Blending Modes and their basic descriptions are listed here. The best way to learn about these effects is to try them out on your projects. Start with a digital photo and add a texture photo to it. Apply a Blending Mode to this new layer, and see what happens!

You can adjust the Blending Mode of a layer by clicking on the layer in your working file or in the Layers palette. Then make a selection from the Blending Mode drop-down menu located at the top of the Layers palette (see Fig. 12).

Normal is often considered the default mode or threshold. Choosing this mode will not alter your imagery.

Dissolve results in a random replacement of the pixels, producing a dissolved effect.

Darken selects the base or blend color (whichever is darker) as the result color.

Multiply multiplies the base color by the blend color, so the result color is always darker.

Color Burn darkens the base color to reflect the blend color by increasing the contrast.

Linear Burn darkens the base color to reflect the blend color by decreasing the brightness.

Darker Color displays the lower value color.

Lighten selects the base or blend color, whichever is lighter.

Screen multiplies the inverse of the blend and base colors. The result color is always a lighter color.

Color Dodge brightens the base color to reflect the blend color by decreasing the contrast.

Linear Dodge brightens the base color to reflect the blend color by increasing the brightness.

Lighter Color displays the higher value color.

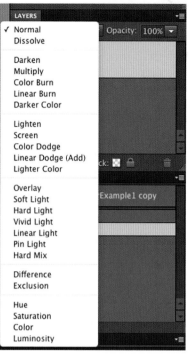

FIGURE 12

Overlay multiplies or screens the colors, depending on the base color. The highlights and shadows of the base color are preserved.

Soft Light darkens or lightens the colors, depending on the blend color.

Hard Light multiplies or screens the colors, depending on the blend color. The effect looks like a bright spotlight.

Vivid Light burns or dodges the colors by increasing or decreasing the contrast, depending on the blend color.

Linear Light burns or dodges the colors by decreasing or increasing the brightness, depending on the blend color.

Pin Light replaces the base color with the blend color, sometimes producing no change, depending on the tonal values.

Hard Mix adds the red, green and blue channel values of the blend color to the RGB values of the base color, therefore changing all pixels to primary and secondary colors—red, green, blue, cyan, yellow, magenta, white or black.

Difference subtracts either the blend color from the base color or the base color from the blend color, depending on which has the greater brightness

value. Blending with white inverts the base color values, and blending with black produces no change.

Exclusion creates an effect that is similar to Difference, but lower in contrast.

Hue creates a result color with the brightness and saturation of the base color and the hue of the blend color.

Saturation creates a result color with the brightness and hue of the base color and the saturation of the blend color.

Color creates a result color with the brightness of the base color and the Hue and Saturation of the blend.

Luminosity creates a result color with the hue and saturation of the base color and the brightness of the blend color. This mode creates the inverse effect of Color mode.

Note that you can adjust the opacity of a layer that you applied a Blending Mode to. I often do this if the effect is too harsh with the Opacity set at 100% (the default).

Applying Filters, Layer Styles and Photo Effects

You can access filters in two ways—either by going to the Filter menu at the top of your screen (see Fig. 13), or by going to the Effects Palette (see Fig. 14) located above the Layers Palette. The Effects Palette provides numerous possibilities for your imagery—the effects are categorized by Filters, Layer Styles and Photo Effects (see the icons at the top of the Effects Palette). In the Effects Palette you can see thumbnails that demonstrate the look of each effect. (Note: If you want to preview and adjust various filters on your actual imagery, go to **Filter>Filter Gallery**.) What follows is a description of the filters you'll apply to the projects in the book, though there are many more filters to try.

UNDERPAINTING FILTER
Filter>Artistic>Underpainting: This filter makes your imagery appear as if it were "painted" onto a textured background. You can alter the brush size, texture coverage area and texture options. Texture options are canvas, brick, burlap or sandstone.

GAUSSIAN BLUR FILTER
Filter>Blur>Gaussian Blur: This effect will blur a selection, allow you to adjust its intensity and add a dreamy cast to your imagery.

ADD NOISE FILTER
Filter>Noise>Add Noise: This filter places pixels on your image in a random fashion, replicating the look of photographs shot with high-speed film. It can also be used to give a more realistic look to highly edited areas of your imagery, or to create texture on a layer. You can alter the amount of noise, the type of noise distribution and color mode. The Uniform setting creates a less intense distribution of random pixels while Gaussian creates a speckled style. Monochromatic uses existing tones of the image, thus maintaining the original colors.

LIQUIFY FILTER
Filter>Distort>Liquify: With this filter you can manipulate areas of your image so they appear "melted." It allows you to warp, twirl, expand, contract, shift and reflect areas of your image. You can adjust the intensity of this filter to yield either subtle or dramatic effects.

FIGURE 13 FIGURE 14

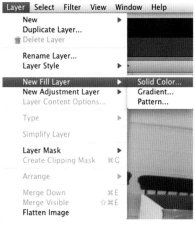

FIGURE 15

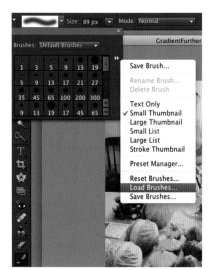

FIGURE 16

FIGURE 17

CHARCOAL FILTER

Filter>Sketch>Charcoal: Use this filter to create a smudged effect where strong edges become further defined and midtones convert to diagonal strokes. Charcoal is the foreground color you select, while the "paper" is the background color you choose. Further settings allow you to adjust charcoal thickness, level of image detail and light/dark balance.

Layer Styles

BEVELS

The Bevels feature allows you to add a variety of beveled edges to your imagery, which is perfect for creating a framed look for your photos.

FILL LAYERS

There are two types of Fill Layer effects that you can use to alter your layers (please note these are different from the Photo Effects available in the Effects Palette).

SOLID COLOR FILL LAYER

Layer>New Fill Layer>Solid Color: (see Fig. 15): You can apply a layer of solid color to your imagery with this effect. I often use it to tint a photo or elements of a photo. You can apply a Blending Mode to this type of layer to produce additional interesting effects and reduce its Opacity level to produce more subtle colorizing effects.

GRADIENT FILL LAYER

Layer>New Fill Layer>Gradient: A gradient is the smooth blending of shades from light to dark. Gradient Fill Layer produces this kind of effect. You can apply a Blending Mode or change the opacity of a Gradient Fill Layer. This can be done either in the Gradient Fill Layer menu (see Fig. 16) or in the Layers Palette.

Miscellaneous Techniques

FEATHERING EDGES OF A SELECTION

To soften or blur the edges of a selection you have made with one of the Lasso tools, go to Select>Feather. You can set the Feather Radius as desired—the higher the number, the greater the feathering effect. Some of the details on the edge of the selection will be lost. You really notice the effect of this tool when you move the selection to your desired spot.

LOADING A CUSTOM BRUSH

If you download a custom brush, you will need to load it into the Brushes menu, which is located in the upper left-hand corner of the Brush toolbar. To load a brush or brushes from a folder on the hard drive to the Brushes menu, you'll need to first select the Brush Tool from the Tools Palette and then click on the double arrow on the right-hand side of the Brush Menu and select Load Brushes (see Fig. 17). Follow the steps to retrieving your brushes from their folder on the hard drive. Your set will appear in the Brushes menu. Keep in mind that if you switch to another brush set, your newly loaded set will probably disappear. If you wish to use that custom set again, you will have to reload it from your hard drive.

RESIZING

To resize a layer, select the Move Tool, then click on the layer (in your working file) and drag on the hollow squares located at the edges and corners of the image.

Press the Shift key while resizing your object to maintain its proportions.

ROTATING AND FLIPPING

The rotating and flipping options are located at **Image>Rotate** (see Fig. 18). The first six choices allow you to rotate or flip the entire working file. The next six allow you to rotate or flip a layer.

ROTATING FREELY

First select the Move Tool. You can free-rotate a layer in two similar ways: (1) select the layer, then click on the hollow circle at the bottom center of the layer (see Fig. 19) and drag to rotate, or (2) select the layer, place your cursor on top of one of the hollow squares until it becomes an arched arrow, and then drag to rotate. Make sure the Move Tool is selected before rotating. To rotate a layer a specific number of degrees and/or in a specific direction, go to **Image>Rotate**.

UNDO HISTORY

The Undo History feature (**Window>Undo History**) lets you go back to any recent state of the image created during the current work session. Each time you apply a change to pixels in an image, the new state of that image is added to the Undo History panel.

A few tips for using this feature:

∞ The Undo History panel lists 50 previous states. Older states are automatically deleted to free up more memory for the program. You can change the number of states displayed in the Undo History panel in Performance Preferences (**Edit>Preferences>Performance**). The maximum number of states is 1,000.

∞ The original state of the photo is always displayed at the top of the Undo History panel; i.e., the oldest state is at the top of the list and the most recent one is at the bottom.

∞ When you close and reopen the document, all states from the last working session are automatically deleted.

∞ Selecting a state and then altering the image deletes all states that came after it. Also, deleting a state deletes that state and those that came after it.

∞ To delete the list of states from the Undo History panel without changing the image, choose Clear Undo History from the panel menu or choose **Edit>Clear>Undo History**. Clearing will free up memory, but please note that this maneuver cannot be undone.

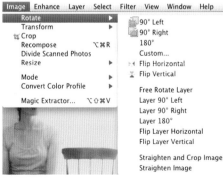

FIGURE 18

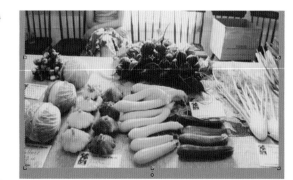

FIGURE 19

Using Tools

We've already discussed some of the tools (Move, Lasso, Brush). Below are explanations of other tools in the Tools Palette (see Fig. 20) that you will be using in the projects. Note that each tool has its own toolbar with further options located at the top of the screen when the tool is selected.

BLUR TOOL

This tool blurs details and makes edges softer. The more you go over an area with this tool, the blurrier it becomes.

BRUSH + PENCIL TOOL

Both the Brush Tool and the Pencil Tool (see Fig. 21) are for painting and drawing. The Brush Tool makes softer strokes than the Pencil Tool. You will notice that the Impressionistic Brush is discussed in Chapter 3. You can find the brush in PSE by clicking on the small tab located at the bottom right of the Brush Tool icon in the Tools Palette.

You can chose your Brush type and adjust Size, Mode (blending mode) and Opacity in the Brush Toolbar at the top of the screen. You can also explore additional options in the Additional Brush Options box (just click on the paintbrush icon to the right of the Opacity setting). You can choose various brush presets when using a variety of tools besides the Brush and Pencil tools.

CROP TOOL

Cut out unwanted portions of your imagery with this tool. Select the portion of the image that you want to keep and click on the green checkmark at the bottom right corner of the selection to perform the crop. In the toolbar you can choose a standard ratio size or specify a custom size for your crop.

ERASER TOOL

I use this tool to clean up the edges of selections and other undesirable areas. For best results, zoom in on an area (using the Zoom Tool). If you select a background color and use the eraser, it will apply the background color you selected. If you have not selected a background color, it will make the pixels you erase white (or transparent if your file is transparent).

MARQUEE TOOL

Use this tool to make an elliptical or rectangular selection. If you want to make a circular or square selection, press the Shift key when selecting.

TYPE TOOL

If you choose this tool and click in your working file, a blinking line will appear. You can begin typing just as you would in a document, entering and editing the type in much the same way. In the toolbar, you can choose a font and color, adjust its size and style and select alignment. You can create warped text (the *T* over the arch—see Fig. 22) and change text orientation (to the right of the warped text icon). The best way to discover possibilities is to play!

ZOOM TOOL

This tool is a favorite of mine when it comes to doing detail work in conjunction with other tools. The Zoom Tool is located at the top of the Tools Palette. In the toolbar, chose "+" and click on your project to zoom in close. Choose "−" to pull back to actual size or smaller. You can also press the Option (Alt on a PC) key to change the zoom direction.

FIGURE 20 FIGURE 21 FIGURE 22

What You'll Need

The *What You'll Need* section at the beginning of each project tells you what digital materials you will need to complete the project as well as what techniques you will need to know how to perform. Keep in mind the following information as you go through the projects.

Digital Materials

This section outlines all the necessary types of digital files/materials you will need to complete the projects. I recommend gathering all your materials prior to starting a project.

SUBJECT PHOTO

This will be the focus of your digital art. The subject need not be a person (an animal or still life might work for the project).

TEXTURE PHOTO

You'll want to choose from a variety of texture images to find just the right textural application for your photo.

FONTS

You can use fonts installed on your system or download free ones from the Internet.

CUSTOM BRUSHES

These brushes are not already installed in the program. You can find them online for free or for a minimal cost. In most cases, when a project calls for a custom brush, you can substitute one of the program's preinstalled brushes to create a similar look.

SCAN OF ORIGINAL ART

If you don't have access to a scanner, a visually clear, cropped photo of the piece will also work.

Technical Skills and Tools

The instructions for each project are intended to show you how to build various types of digital art. Many of the tools and techniques are similar among the projects. As such, the project instructions do not include information about the essential techniques and tools described in this section of the book. These sections outline the essential techniques you will need to know how to perform in order to complete a project and list the tools you will need to know how to use.

SAMPLE TEXTURE PHOTO (BY CHRISTY HYDECK)

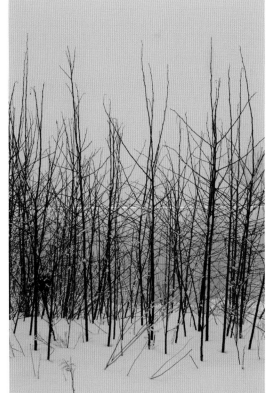

SAMPLE SUBJECT PHOTO (BY SUSAN TUTTLE)

TAKING GREAT PHOTOS

1

Every once in a great while, you win the photography lotto and luck into an amazing, award-winning shot. But more often than not, great photos don't just happen—it takes careful planning, sound execution, and creative post-processing to create images that stand out from the crowd. You don't need to be a master of photography to enhance your imagery, but sharpening your skills can lead to stronger images, and stronger images often need less time-consuming touchups—an added bonus.

Christy

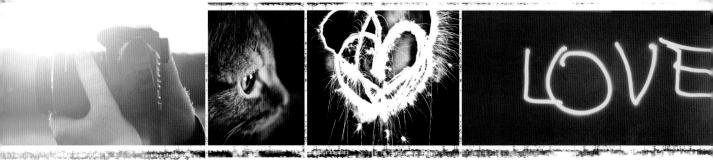

❯ THE BASICS

1. REMOVE THE LENS CAP!

If you think I added this because there have been countless times that I myself have forgotten, then you would be 100% absolutely correct.

2. SHOOT IN RAW.

If your digital camera has the ability to shoot in RAW format, do it. Forget the JPEGs. In digital terms, a RAW file is the equivalent of undeveloped film and a JPEG is the developed photo. Working with the RAW format will allow you to correct critical issues like white balance, exposure, saturation and so much more, without any loss of image quality. You can still save the corrected files as JPEGs to share. I resisted this for years and came to regret it. Give it a try; don't take my word for it!

3. LEARN YOUR CAMERA.

Your camera should be your new best friend. It should go everywhere with you, so take the admittedly tedious time to study its manual. Learn every little thing about it, and it will treat you well in return. In the long run, it really will save you time and frustration.

4. PRACTICE, PRACTICE, PRACTICE.

Make it a habit to take photos daily. The camera you use doesn't matter, but the act of taking the photo does. Take photos of everything and anything—your kitchen sink, a pair of shoes or even the view from your bed as you wake up in the morning. Wherever you are there is always a photo opportunity. There is no better way to improve at photography than to simply do it and do it often. You'll be amazed at how your skills will grow.

Yes! You absolutely can create stunning photographs, and it is easier than you may think. The beauty of the digital camera is that you can snap away to your heart's delight without wasting film, money or even time. Chances are you are going to capture some pretty special moments, and if you get at least one good shot, than you have succeeded! In this chapter, we will give you many tips for taking great photos and we'll teach you a few basic tricks for digitally improving your photos prior to using them in the projects for this book.

Susan

RAINING LIGHT BY CHRISTY HYDECK

PHOTOS BY CHRISTY HYDECK

susan's tips for taking great photos

∞ *Get close for portrait photography, especially when taking photographs of children, as they have such perfect faces and big round eyes.*

∞ *Try shooting your subject matter from a variety of viewpoints (from above, at the same level, looking up, from different angles), sampling different focal lengths. Carefully compose shots where the subject matter is mostly or completely still, for example, a landscape or still life. If you are photographing a subject that has movement or are taking candids, don't worry so much about composition. Instead, keep snapping away or you might miss a special moment. Technical corrections can be made afterward in Photoshop.*

∞ *Avoid using flash. It yields unnatural results most of the time.*

∞ *Avoid busy backgrounds when photographing a person or object.*

∞ *Be aware of your light source, where the light is coming from and the degree of its intensity. I prefer to shoot photos in morning and early evening sunlight—it's softer, shimmers and has a golden hue, as opposed to midday full sun, which can be too harsh. Overcast and partly sunny days also make for great lighting.*

∞ *Take vertical as well as horizontal photographs of the same subject to see which best captures your subject.*

∞ *Compose photos in which your focal point is not always in the dead center of the composition. Experiment with putting your subject matter in a corner of the composition or slightly off center.*

∞ *Make sure your subject matter is focused and clear.*

∞ *Keep it simple.*

IMPROVE PHOTOS DIGITALLY

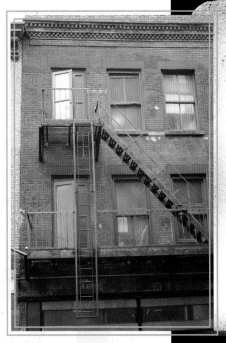

You can apply the following techniques to your photographs prior to doing the digital projects in this book to ensure you are getting the most out of your photos. In fact, you can make a good photo *great* with a few easy tricks like sharpening your images, using the Crop Tool to create more appealing compositions, achieving tonal balance and enhancing color and using the Clone Stamp Tool to remove any unwanted objects or pixels in your photos.

A single photo demonstrates sequential application of the techniques below. Please note that these manipulations can be done in any order, and you can apply them as needed to your photos.

Susan

ORIGINAL PHOTOGRAPH

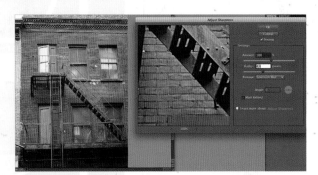

SHARPEN YOUR IMAGES

Sharpen Your Images

The sharpening tools that Photoshop has to offer come in handy when you wish to recover lost detail or give your images a crisp, clean, clear appearance. Be careful not to sharpen too much as your image will begin to look unnatural and grainy. It's best to start out with a little bit of sharpening and increase it gradually as needed to avoid a grainy look.

When I sharpen my images, I go to **Enhance> Adjust Sharpness**. The Amount refers to the strength of the sharpening applied (I generally keep this somewhere between 100% and 115%). Radius refers to the width of the sharpening effect (I generally set mine anywhere from 3 to 6 pixels). Remove allows you to select the type of blur you wish to have removed from the photo (I generally keep it set at Gaussian Blur, which is the default setting).

You can also use the Sharpen Tool located in the Tools palette to brush over any isolated areas of the photo that you wish to sharpen.

USING THE CROP TOOL TO
ENHANCE YOUR COMPOSITION

Use the Crop Tool for More Appealing Compositions

The Crop Tool is magnificent for making compositions stronger and more focused. You can crop out unwanted objects and clutter, get rid of expansive space that does not lend itself to the photo, hone in close on your subject and achieve interesting effects by cropping in unexpected places (This is my favorite thing to do and there is no hard and fast rule for this particular technique. Just experiment, experiment, experiment!). I enjoy using the Zoom Tool to hone in on my subject. Often I find something I like about the composition when I do this, so I crop the photo to capture the point of view I can see after zooming in.

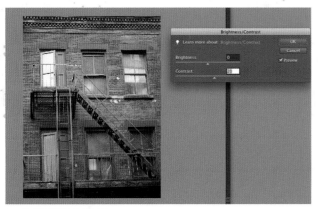

ACHIEVE TONAL BALANCE

Achieve Tonal Balance

You can make sure that your photo isn't too light or too dark with a few digital adjustments. Go to **Enhance> Adjust Lighting** and you will see three different options to experiment with to achieve just the right tonal balance. They include Shadows/Highlights, Brightness/Contrast and Levels.

With Shadows/Highlights you can lighten or darken shadows and highlights and adjust midtone contrast with the given sliders. **Enhance>Adjust Lighting>Shadows/Highlights**.

For Brightness/Contrast you can increase or decrease each of these components. When you increase the contrast level, you can really make your photos pop, meaning you can make an object more distinguishable from other objects and the background. **Enhance>Adjust Lighting> Brightness/Contrast** or **Layer>New Adjustment Layer>Brightness/Contrast**.

You can do any of the following with the Levels dialog box:

∞ *Set the shadow and highlight values to make sure your image uses the full tonal range.*

∞ *Adjust the Brightness of the image's middle tones without affecting the shadow and highlight values.*

∞ *Target shadow and highlight RGB values (use the Channel pull-down menu to adjust Red/Green/Blue values together or choose individual colors to adjust).*

∞ *Enhance>Adjust Lighting>Levels or Layer>New Adjustment Layer>Levels.*

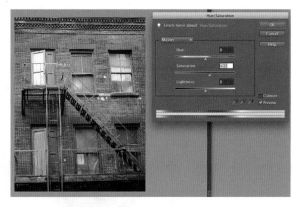

ENHANCE COLOR

Enhance Color

Add vibrancy to the colors in your photographs by increasing their saturation. You can manipulate the saturation of your piece as a whole by using the Master setting, or you can individually manipulate each color. If you are going for a softer, more vintage effect, you may want to desaturate your color(s). Be careful not to increase colors too much as they can look garish and unnatural. Go to **Enhance>Adjust Color>Adjust Hue/Saturation** or **Layer>New Adjustment Layer>Hue/Saturation**. You can also adjust color with Color Curves.

Remove Unwanted Pixels with the Clone Stamp Tool

I cannot live without the Clone Stamp Tool, as it allows me to remove unwanted pixels and replace them with surrounding pixels to make it appear as if the unwanted object was never there. For example, let's say I have a photograph of a lovely stretch of green grass in a park with the perfect sunset behind it, only there is a trash can in the scene, taking away from the pristine beauty of the landscape. With the Clone Stamp Tool, I can pick up pixels from the surrounding area and replace the trash can with those pixels. If the can also happens to be against part of the sky, I can clone parts of the surrounding sky and paint over the trash can in that area.

REMOVE UNWANTED PIXELS
WITH THE CLONE STAMP TOOL

To use the Clone Stamp Tool (found in the Tools Palette), simply select the tool, set the Size, Mode (Normal) and Opacity at the top of your screen, and then hover over an area you want to clone (copy). Press the Option/Alt key on your keyboard to clone the area, then let go. Move your mouse or graphic pen over the object, press the mouse or pen, and begin to paint over your unwanted object. You can see it pick up the cloned area (you will see a + sign where it does that) and watch the new pixels cover the object as you paint away. You can clone and stamp multiple times in different areas to get just the right natural look. Experiment with Opacity— sometimes 100% will work fine, and other times it will be too harsh. If so, reduce the Opacity to around 80%. Experiment to find just the right setting(s). In the photo, you can see that I used this tool to replace the brick discolorations with the regular brick color/pattern, and I removed a small side part of the railing in the left corner.

christy's notes for improving photos digitally

These seemingly small tips can make an absolutely enormous difference in the impact your photos have. Often, subtle changes yield amazingly powerful results and can elevate your photography to another level. These slight modifications can be easily carried out within most graphics programs. As each program is different, consult your user's manual for specific instructions. (And in case you were wondering, my photo-editing software of choice is Adobe Lightroom.)

straighten up!

Standing on uneven ground, rushing to get a shot, not realizing the camera isn't level—a plethora of reasons explain why we end up with uneven photos. And, we all do. It's an entirely too common issue that can detract from an otherwise great photo.

When a photo is at an uncomfortable angle, our eyes lack a resting spot and try to compensate for it, making it awkward to view the photo. Worse yet, we lose the focal point within the photo as the lines tend to overpower it. Even photos intentionally taken at an angle have natural resting points and lines that need to be straight to engage the viewer in a pleasing manner.

In landscape photos, check to make sure your horizon lines (where the sky meets the ground) are indeed horizontal.

THE CROOKED HORIZON LINE UNINTENTIONALLY BECOMES THE FOCAL POINT IN THIS PHOTO AND PLACES A STRAIN ON THE EYES.

WITH A STRAIGHTENED HORIZON LINE, THE FOCAL POINT IS AS IT SHOULD BE AND THE PHOTO IS MORE IMPACTFUL.

expose yourself!

Overexposed. Underexposed. The lightness or darkness of your photo can make or break it. Overexposure causes it to be too bright and the resulting white washes out detail. Underexposure makes for a too dark photo and detail will be lost here as well. Thankfully, you can work with this a bit in post-processing! The best way to correct exposure issues is by shooting in RAW mode (see Chapter 1, The Basics, for more on shooting in RAW) so you don't lose any quality in the image itself.

IN THIS OVEREXPOSED PHOTO, TOO MUCH LIGHT WASHES OUT THE DETAILS AND COLORS WITHIN THE SCENE.

ALWAYS TAKE THE HIGH ROAD
BY SUSAN TUTTLE

The definition of depth of field (commonly referred to as DOF) can be explored at length, but basically it is the distance between the nearest and farthest in-focus elements of a photograph. Shallow depth of field indicates a short distance between these elements (i.e., the foreground is clear and the background is blurred). Large or great depth of field means that there is greater distance between these elements and sometimes complete sharpness of elements from foreground to background. Taking photographs that have a shallow DOF should require an expensive camera lens with a long focal length capability. But with Photoshop, you can create the illusion of shallow DOF in just a couple of super easy steps.

Susan

WHAT YOU'LL NEED

DIGITAL MATERIALS
Subject photo

TECHNICAL SKILLS
Duplicating a file

Feathering

Applying the Gaussian Blur Filter

USING TOOLS
Rectangular Marquee Tool

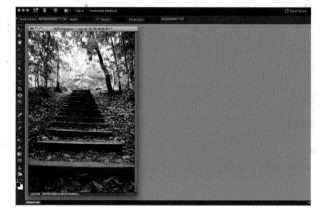

1 DUPLICATE SUBJECT PHOTO.
Duplicate your subject photo. This will be your working file.

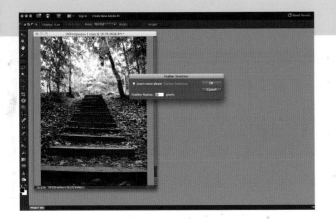

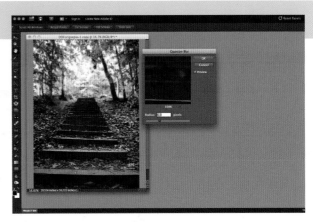

2 SELECT BACKGROUND AND FEATHER IT.

With the Rectangular Marquee Tool, select the portion of the background you wish to blur. Feather this selection (I used a Feather Radius of 50).

3 BLUR BACKGROUND.

Apply a Gaussian Blur Filter (I used a Feather Radius of 6.3 pixels). Save file.

tips • prompts • variations

∞ Photos that work well for this technique include ones in which strong subject matter appears in an uncluttered foreground and the subject matter recedes into the background.

∞ You can use limited DOF to emphasize one part of an image—this is often referred to as selective focus, differential focus or shallow focus. The point of focus is often called the "sweet spot." Use either a Marquee Tool or Lasso Tool to select your area of focus, feather it, Select> Inverse to select the area(s) outside of the focal point, and then apply a Gaussian Blur Filter to these outside areas.

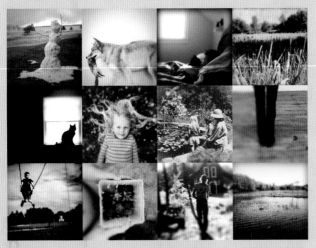

IPHONEOGRAPHY MONTAGE: SEVERAL GREAT EXAMPLES OF DEPTH OF DIFFERENTIAL FOCUS. SEE THE ONLINE RESOURCES SECTION AT THE BACK OF THIS BOOK FOR MORE INFORMATION ON IPHONE DOF APPS.

THE EYE OF THE SOUL BY SUSAN TUTTLE
THIS EXAMPLE HAS A FAUX SHALLOW DEPTH OF FIELD CREATED BY THE APPLICATION OF A RADIAL BLUR WITH A MILD ZOOM SETTING TO THE BACKGROUND.

Like an unsharpened pencil, a photograph with no point doesn't convey a message. Is there a clearly defined subject? What feeling are you trying to invoke? Before you press the shutter button, ask yourself what story you are telling within the frame. Beginning a photograph with this approach often leads to a stronger composition, which in turn, yields a much stronger image. As with any art form, there are no hard and fast rules that you need to follow, but through experimentation you will discover common elements that help create your story. The tips that follow are a few of my favorite ingredients for achieving amazing visual stories.

Christy

THE RULE OF THIRDS

ALL HAIL THE RULE OF THIRDS (AND THEN BREAK IT!)

Imagine a grid of nine blocks (like a tic-tac-toe board) overlaying your photo, breaking the photo up into thirds both horizontally and vertically. Create an interesting imbalance by placing your subject at an intersecting line of thirds. It's a fabulous general guideline to increase the power in a photograph (But we all know dramatic images can also be made when the rules are broken, right?)

LOOK FOR LEADING LINES

Leading lines draw the viewer's eye to the subject in a photograph. Use natural formations of trees, a river, a road or even clouds in the sky to bring attention to the main focus of the image. The lines don't have to be straight, *S* shapes always guide the eye nicely. In many great images, a point for the eye to rest prevails, and leading lines serve as the ushers to get the eye to travel to that point.

LOOK FOR LEADING LINES

IF YOU SEE RED, SHOOT IT

Pops of red almost always elevate an ordinary photo to extraordinary. Think: red barns in a white snow scene, a single red umbrella in the cold and dreary rain, red shoes on pavement. While red is one of the most visually striking colors, this applies to all pops of color in an otherwise monochromatic scheme.

IF YOU SEE RED, SHOOT IT

CUT THE CLUTTER

Painters have to decide what to add to a picture; a photographer chooses what to leave out. Approach each photo with that in mind, keeping an eye out for any distracting elements within your frame.

BALANCING ACT

Whether it is art or photography, every image has visual weight. Symmetry almost always creates a balanced image, but using a combination of large and small objects in a nonsymmetrical fashion can as well. A well-balanced photograph is a combination of lightness, darkness and forms spread out in a way that draws the eye to each item equally. For example, if you have a large subject on one side of the image, you'd want to balance it with a smaller object on the opposite side. Visualize the photograph being folded in half; will there be an element of interest on either side?

REVISIT GEOMETRY

Geometric shapes can greatly enhance any composition. Look for elements within a photo to form triangles, as the shapes will strengthen the lines and balance in almost any shot. I'm not talking literal triangles, but things like people whose bodies form a triangle within the composition. Learn to see that negative space and what shape it forms.

ODD NUMBERS HAVE IT

Have you noticed that in photographs, subjects in odd numbers are stronger as a whole than those in even numbers? The odd number typically creates a visual center, a place for the eyes to rest. Ever since I learned this rule, I see it everywhere and hope you will too.

BALANCING ACT

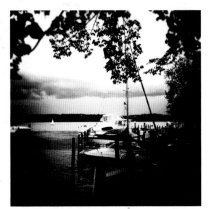

NATURAL FRAMING

NATURAL FRAMING

Add interest and depth to your images by taking advantage of nearby elements to frame the foreground of your shot. Photograph a face through a window using the architecture as a frame. Use tree trunks on the side and branches overhung at the top to shape a landscape shot. Tunnels, bridges, keyholes and other people also work. As long as at least two sides of your image have the framing elements, you should be good to go.

LOOK UP

Most people look at what is in front of them dead on, at eye level. By looking up and altering your perspective, things become a bit more interesting. Not only will you notice things you may have missed before, but you'll offer the viewer a unique perspective as well.

THIS PHOTO DEMONSTRATES A STRONG HORIZONTAL COMPOSITION, IN WHICH I PURPOSELY OFF-SET THE SUBJECT TO MAKE THE PHOTO AS INTRIGUING AS IT IS WHIMSICAL. (IT ALSO SHOWS HOW BREAKING THE RULE OF THIRDS CAN SOMETIMES WORK.)

UP BY SUSAN TUTTLE

Warning: Tissues may be required. You can take as many photos as you want, but without an emotional tie, a good photograph is just, well, a good photograph. Of the many thousands of photographs I've viewed throughout my lifetime, only a handful have never left my memory. The photos are etched in my memory, haunting me in their own sort of way, and they each share one common element: emotion. They were immensely powerful, showcasing pure joy and celebration and often pain and sorrow—genuine, heartfelt moments encapsulated in time. Images that invoke such feelings are compelling and transcend time and distance. More often than not the photographer had a strong emotional connection to the scene they witnessed through their viewfinder.

Christy

Whether it's a shot of a soldier returning home to his family, a team hoisting the championship trophy in a moment of unadulterated happiness, or preserving a moment in a life that's fleeting all too quickly—each image stirs a different emotion deep within our beings. Somehow we can relate to the feeling of the image, even if we don't personally know (or have a vested interest in) the subject. The magic of photography is that it can pull us away from ourselves —if even just for a moment—and make us see the world through another's eyes.

Some of the most gut-wrenching shots I've taken were of my little orange kitten, Ben. He was just a scrawny little thing … left out in the cold, hungry, all skin and bones. The day he came into my life he had been run over by a car. We got him to the vet, nourished him with food and a warm place to snuggle. The way he looked at me was unlike anything I'd seen or experienced before. His eyes met mine in a way that conveyed pure love and utter gratitude. I knew I was in trouble almost immediately!

If there was one thing I could tell you about little Ben, it was that he was resilient. He made an amazing recovery, healed from his surgeries and was declared in good health—perhaps a little too good! He would get into places that really made you scratch your head trying to figure out exactly how he did it. He kept me up at night playing with anything that moved under the covers. He was full of mischief and often lovingly tormented my other animals. But those eyes! They could melt me … there was no way to stay mad for long. (I still think he knew he could look at me and all would be forgiven; he was intuitive like that.) But as things sometimes go, little Ben suddenly got sick again. Only a few short months in this world and his kidneys were failing. There was nothing to be done except to try to make him as comfortable as possible and make the best of his last days with us. It was a decision I wrestled with and one that, in the days that followed, I questioned heavily. I'm still not sure why I reached for my camera that day. Through teary eyes, I took a handful of

photographs, in what turned out to be his last hours on earth. Photographs of him that are still incredibly hard for me to look at … but I'll tell you, I wouldn't trade them for anything in the world. You see, I didn't fully accept his death until I mustered the courage to look at those last, precious few photographs a few months later. All I needed to know was in his eyes. They had lost their innocence and his pain was evident. They seemed to be pleading with me, straight through the photograph. After that, I slowly began to make peace with the tragedy of losing him.

I'd urge you to look not just at the many, many joyful moments life offers us to document, but to consider the heart-wrenching ones as well. The photos don't have to be kept where they are readily available, and they can easily be hidden for viewing at a time of your choosing. Our journeys consist of both joy and sorrow. Those not-so-happy photos that tug at you still tell a part of your story. Personally, I discovered that the raw truths that are unearthed within the unpleasant times not only make for a compelling image, but can often alter my viewpoint on life itself and serve as a reminder of all the blessings I am fortunate enough to have.

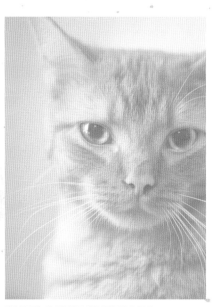

HIS EYES SPOKE BY CHRISTY HYDECK

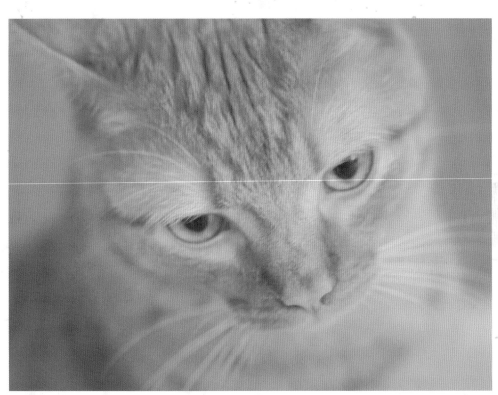

LETTING GO BY CHRISTY HYDECK

susan's notes on emotional ties to photographs

Converting your photographs to black and white with a program like Photoshop can produce a number of visual effects and evoke interesting responses from your viewers. This conversion can enhance a photograph's emotional content, add impact and drama, produce a more elegant and/or formal look, and bring into focus details that might otherwise get lost in the mix of a multicolored photo.

There are no hard and fast rules in terms of what types of photographs look best in black and white. You can apply black-and-white toning to portraiture, landscape and nature shots (like Ansel Adams), and even still-life photography. And if you feel that the photograph was more effective in color, you can revert to its original state with a click of a button in Photoshop.

Photographs with sepia tones will give a soft vintage romantic flavor to your work. I often like to use this toning with photographs of children, as it tends to match their softer, more innocent natures and features.

CONVERTING YOUR PHOTOS TO MONOTONE ...

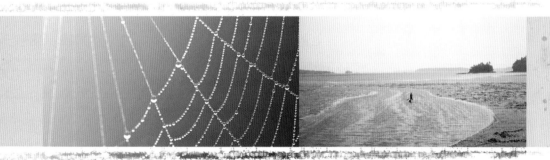

... CAPTURES BEAUTY AND ELEGANCE IN NATURE ... INCREASES THE DRAMATIC EFFECT OF A MOMENT

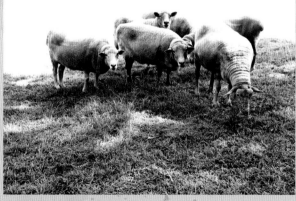

... AND BRINGS INTO FOCUS THE DETAILS OF YOUR SUBJECTS, ESPECIALLY IF THEY ARE SET AGAINST A TEXTURED, "BUSY" BACKGROUND.

PASTURE BY SUSAN TUTTLE

GUEST SPOTLIGHT: 3-D IMAGES

➤ Claudine Hellmuth

So much internal heaviness surrounds losing someone you love that it's only natural to want to break free from that and celebrate life, in all its wonder and glory. I fell in love with Claudine's Sitting Pretty Pet Poppets® instantly; their whimsical, fun nature lightened my heart. I began commissioning her to create these 3-D sculptures of all the fur babies that have entered my life over the years. Five down and still plenty more to go! It is impossible for me to walk by them without smiling ear to ear.

Claudine begins her Sitting Pretty Poppets with a photo. She transfers the image onto flexible, metal roof flashing and uniquely designs each piece with illustration, fabric, paint and paper for a one-of-a-kind personal piece of art. Through her website (www.claudinehellmuth.com) you can find tutorials to create or order your own special keepsake.

SITTING PRETTY POPPETS BY CLAUDINE HELLMUTH
PHOTO TRANSFER, METAL ROOF FLASHING, FABRIC, PAPER AND PAINT MAKE FOR PERSONALIZED ARTWORK.

➤ FOCAL POINT

document your day with a cell phone camera

There is something extraordinary to be found in ordinary, everyday moments of life—like the way dappled morning light plays upon your knotty pine floor, the gentle curve of the handle of your favorite blue pottery mug, tiny rainbows nestled in your dishwater bubbles and brimming bins of colorful fruits and vegetables at the roadside farm stand.

For this assignment take your cell phone camera (or any camera you wish) everywhere you go (and document a day in the life filled with these beautiful moments. This practice will open your eyes to the abundance of beauty in the simplest things. And with this appreciation, you will begin to notice more and more surprises, possibilities and miracles that happen each day of your life.

Susan

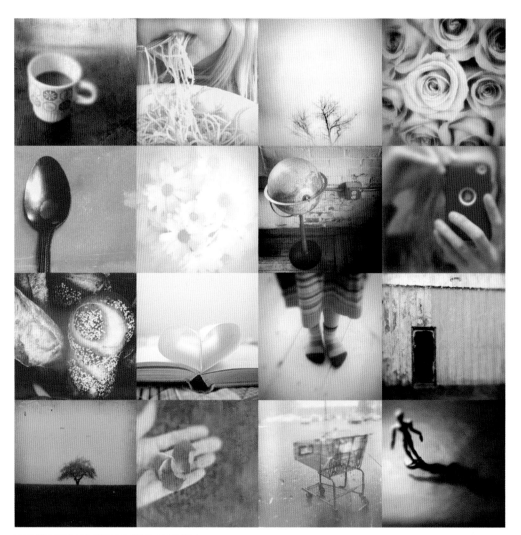

YOU WILL FIND THE EXTRA IN YOUR ORDINARY.

TRY FRAMING YOUR SUBJECT MATTER IN UNIQUE WAYS.

field trips + photo shoot
idea list

∞ *Walk one hundred steps, find something interesting where you stand, and photograph it.*

∞ *Take photographs that break the rules. For example, try moving away from shooting with the rule of thirds in mind; instead, try placing subject matter in a visual strip located at the bottom of your composition.*

CHRISTY'S IPHONEOGRAPHY

iPhoneography

STORYBOARDS MADE EASY

With the swipe of a finger or the shake of a phone, there are apps that will allow you to transform several of your photos into magnificent montages that visually speak your story. Go on, tell it.

Apps to try include Diptic, PhotoShake, PhotoMess and Montage.

A PHOTO A DAY

Alternatively, chronicle your life one photo and one day at a time with the following apps. At the end of a week, month or even a year, glance back through your shots and enjoy not only reminiscing, but seeing how your photography skills have grown.

Apps to try include Project 365 and Photo 365.

SOCIAL SHARING

If you're more the instant gratification type, try one of these social networks made just for sharing your photography with other like-minded souls.

Apps to try include Instagram, Photofon and TaDaa.

ROAD TRIP STORYBOARD WITH THE DIPTIC APP

FOGGY MORNING STORYBOARD WITH THE DIPTIC APP

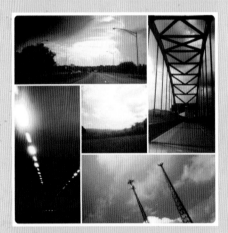

PASSING THROUGH STORYBOARD WITH THE PHOTOSHAKE APP

HOW TO CARVE A STAMP STORYBOARD WITH THE PHOTOSHAKE APP

➤ For more information on Apps, please visit the **Online Resources** section at the back of this book.

If you find chronicling your day to be repetitive or intimidating, try giving yourself mini-challenges throughout the day instead. They help you find beauty in the mundane, make your routine tasks a bit more interesting and sharpen your photographer's eye.

COLOR PALETTE CHALLENGE: RED/PINK AND BLUE/YELLOW

field trip/mini-challenge ideas

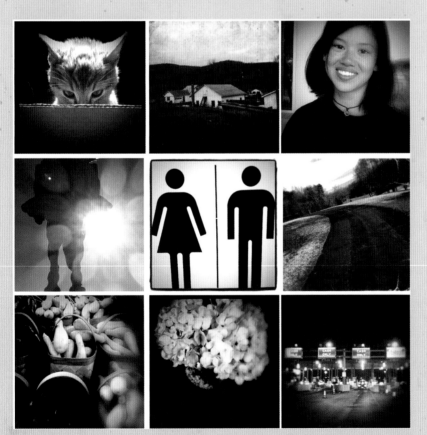

BLACK AND WHITE: SHADOW/LIGHT

∞ Photograph the alphabet. Bonus points for seeing letters where there aren't any. Examples: a round rock as an O, a spiral staircase as a C, a power line as a T.

∞ Color palette challenge. Pick two to three colors like blue and yellow and spend the day photographing just those.

∞ Grocery store. Challenge yourself to document your shopping trips. You may be surprised at how much beauty surrounds your everyday chores.

∞ Lose the color. Convert all your photos to black and white for a day, and see the world through form, shadow and light.

DEFINING PHOTOS THROUGH LIGHT + TEXTURE

2

In its most general terms, form refers to the visual attributes of a subject and the way those attributes work together to define the subject. Such attributes might include color, dimension, line, mass and shape, all of which can be manipulated to yield fascinating results. In this chapter, we will explore form. We will see how it can be defined by highlights and shadows and enhanced by the application of texture layers, both digitally and with "actual" art. You will learn how to transform a photograph into a semi-silhouette, add interest and depth with texture layers, create your own mixed-media background textures, add light flares and give your images a bathed-in-light appearance. We will also show you how to gather a plethora of imagery with which to build your very own comprehensive texture image library.

Christy

Many, many old-school photogs will tell you that everything I am about to say goes against the unwritten rules of photography. And you know what? They're right. Purists tend to think lens flares are intrusive and they don't enjoy the hazy, washed-out look they can give. For them, lens flares are unwanted distractions in an otherwise good photo.

I believe that glorious light gives a spectacularly dramatic and cinematic feel to an otherwise mundane photograph. These otherworldly spheres convey lightness, airiness and pure magic. They reel me right into a photo, invoking both emotion and warmth, as I almost always feel I am bathed in that radiant light upon viewing them.

Embrace the spontaneous flares! While not all will be pleasing to the eye—the ones that make it are totally worth the while. The real trick is learning to control the light and how to use flares to enhance your subject or scene. The following are some of my tried-and-true tricks to achieve more controlled lens flares. But most of all? Experiment! Try different subjects, cameras and lenses, and shoot at different times of the day to see how you can manipulate the light.

ON ALL CAMERAS

Timing is everything. I find that late afternoon is the best time to shoot if you want a flare. There is some scientific mumbo jumbo about the sun burning brighter and all that; I just know it works. Late morning is my second choice. To try to get a flare at other times of the day, get low to the ground and shoot into the sun.

Initially, you just want to block the sun with your subject then step to the side before pressing the shutter. That partial sun obscurity makes a world of difference. Positioning the sun in the corner of your shot can also simplify it. Though it seems obvious, seeing the flare in your viewfinder first helps to ensure you'll get the image you imagine.

JUST FOR DSLR USERS

Flares are so much easier on a digital single-lens reflex camera (DSLR). With the vast array of different lenses comes a bunch of different flare styles. Here are a few basic tips to achieve cool flares.

∞ Remove the lens hood and any filters you may be using.
∞ Go with a low ISO—you can always adjust as needed.
∞ A higher f-stop (F16 vs. F8) typically equals a more defined flare. That closed-down aperture will also give you more defined sun rays.
∞ Shoot in manual mode, with manual focus so that the camera doesn't try to compensate for the light.
∞ Experiment with the Lensbaby creative effects system. These lenses make flares oh-so-easy.

IPHONE USERS:

Each version of the iPhone has the ability to get cool flares, but the iPhone 4 has a spectacular "flaw" that produces these amazingly vibrant red flower flares! Much like with any other camera, simply angle the camera to point directly at the sun, block your view of the sun with the phone, shift it to the side just a bit and snap.

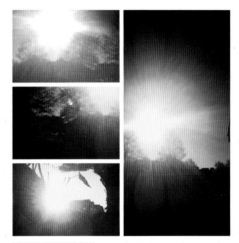

BY CHRISTY HYDECK

susan's notes on lens flare

I added this faux lens flare to my photograph in Photoshop Elements: Filter> Render> Lens Flare. You can choose a lens type, adjust brightness and specify a location for the center of the flare.

I further tweaked the photo by adjusting Hue/Saturation for the blue of the sky, to give it a more greenish/blue—effect, and added a small amount of "film grain" (Filter> Artistic> Film Grain) for texture.

PLACE FAUX LENS FLARES WHERE THEY WOULD NATURALLY OCCUR.

FLOAT BY SUSAN TUTTLE

BATHED IN LIGHT

adding dreamy effects with gradient fills

As photographers, we are seekers of light: the soft awakenings of morning rays illuminating tiny drops of dew, golden-toned backdrops of evening sunset warming figures and flora, heavily contrasted highlights and shadows, dappled magic beneath the leafy trees and landscapes shrouded in gauzy, dreamy light. Did you know that there is a classic feature in Photoshop that allows you to breathe light into your photos, thus giving them an ethereal and serene quality? Introducing the Gradient Light Fill.

Susan

TALKING OVER BREAKFAST BY SUSAN TUTTLE
USE A GRADIENT LIGHT FILL TO ADD A DREAMY
EFFECT TO YOUR PHOTO.

1 Duplicate your subject photo.
This will be your working file.

WHAT YOU'LL NEED

DIGITAL MATERIALS
Subject photo

TECHNICAL SKILLS
Duplicating a file

Adjusting Hue/Saturation

Adjusting Brightness/Contrast

Adding a Gradient Fill Layer

Selecting colors

Adjusting the Blending Mode of a layer

Adjusting the Opacity of a layer

2 Adjust saturation.
Up the saturation of your photograph anywhere from +10 to +15. The Gradient Fill application will dull some of the color, so this maneuver will counteract that.

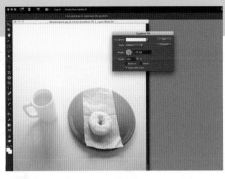

3 Adjust contrast.
Increase contrast anywhere from +10 to +15. This will maintain definition of objects in the photo after application of Gradient Fill.

4 Add Gradient Fill Layer and save file.
First choose a color for fill. In this project I used a peachy/pink tone (#f3eddf). I applied the Fill Layer with the following settings:

> Blending Mode: Normal
>
> Opacity 100%
>
> Gradient: default mode (which is "foreground to transparent")
>
> Style: Linear
>
> Angle: -75.07

Save your file.

tips • prompts • variations

∞ *To decrease the intensity of your Gradient Fill Layer and achieve a more subtle effect, you can reduce its Opacity.*

∞ *Experiment with different colors for your Fill Layers. For more natural looks, I tend to choose either bright white or slightly tinted whites (creams, light pinks and peaches, beige, and sometimes cooler colors like soft mints and powder blues).*

∞ *Try adding more than one Gradient Fill to your photograph, each one at a different angle setting. You may want to play with the Opacity of these layers to soften any harshness.*

∞ *Tip: Sometimes Gradient Fills yield areas that contain artifacts (places where you can see a pixilated surface). You can diminish the appearance of these artifacts by reducing the Opacity of the Fill Layer.*

ENHANCE EXISTING LIGHT SOURCES

ADD SOFT LIGHT TO A PORTRAIT

41

FAUX PLASTER WALL TEXTURE

when carrying around a chunk of a building just isn't realistic

Ever want your art to have an old-world feel without having to wait decades for it to age naturally? Modeling paste replicates that charm by creating cracks and crevices almost instantly. No two applications are ever the same and each piece possesses its own unique story.

Christy

WHAT YOU'LL NEED

ACRYLIC PAINT

Titan Buff, Titanium White, Raw Umber, Black

OTHER

Acrylic glaze

Baby wipes

Brush

Canvas board

Modeling paste

Old credit card or paint scraper

Paper towels

White gesso

OPTIONAL

Heat gun

1 Put paste to canvas.
Use the paint scraper to spread a thick coat of modeling paste on the canvas.

Play with the patterns the scraper leaves until the design is pleasing to your eye. Let the paste completely dry.

2 Add gesso.
Cover the entire canvas with white gesso using a paintbrush, and allow it to dry. This will add subtle texture and better prepare the modeling paste to receive paint.

3 Add paint.
Apply the Titanium White paint and Titan Buff paint in random strokes over the canvas, covering it completely.

Patiently wait for the paint to dry, or use a heat gun to speed up the process.

4 Add glaze.
Mix three parts Raw Umber acrylic paint, a dab of black acrylic paint and five parts acrylic glazing medium together.

Spread the paint mixture over your entire canvas quickly, not letting it dry.

5 Finish.
Use a paper towel to remove most of the paint from the surface. If you want to remove more paint, use a baby wipe. Allow the glaze to stay in the crevices. Don't worry if too much is wiped away; just add a bit more. Create a vignette by leaving more glaze along the edges than in the middle.

feel free to crack up!

For another look, apply a thick coat of modeling paste and then dry it with a heat gun. The heat will cause the paste to shrink, typically leaving large cracks.

FAUX PLASTER WALL TEXTURE FINISHED PIECE

THE RESULT!
CHANGE THE INTENSITY OF THE GLAZE BY ADDING MORE GLAZING MEDIUM TO THIN OUT THE PAINT OR LESS GLAZING MEDIUM TO KEEP IT DARK. ALTERING THE AMOUNT OF PAINT ADDED TO THE MIXTURE CAN ALSO CHANGE THE COLOR VALUES. ALTERNATIVELY, YOU CAN CHANGE THE TONE OF THE PIECE BY ADDING OTHER COLORS. FOR EXAMPLE, ADD BURNT SIENNA TO ADD A WARMER OVERALL FEEL.

CHANGING UP A TEXTURE LAYER
reinvent your photo with Blending Modes

Adding texture to your photograph, whether it be marked and intense or subtle and barely there, can enhance and sometimes completely transform your photo. Photoshop Elements provides many ways to add texture to a photograph. You can scan it and apply a painted background, as in this project, use a textural photographic image or even apply a unique stock photo. Get ready for hours of endless fun as you add textures to your photographs and explore applications of Blending Modes to these textures, yielding endless outcomes.

Susan

WHAT YOU'LL NEED

DIGITAL MATERIALS
Subject photo

Texture photo

SOURCES FOR PROJECT ARTWORK
Texture image created by Christy available online at CreateMixedMedia.com/photo-craft

TECHNICAL SKILLS
Duplicating a file

Moving one file into another

Resizing/Rotating

Adjusting the Blending Mode of a layer

Adjusting the Opacity of a layer

1 Duplicate your subject photo.
This will be your working file.

2 Add texture photo.
Open the texture photo and move it into your working file, placing it over the sapling photo (Background Layer). Resize the texture photo (now Layer 1) as needed to fit the size of the working file.

MULTIPLY 53%

COLOR BURN 80%

3 **Adjust Blending Mode and Opacity of texture layer.**
Experiment with a variety of Blending Modes to achieve the look you want. Reduce the Opacity of the texture layer as needed to achieve desired result. The examples here illustrate a variety of Blending Modes and percentages of Opacity.

LINEAR BURN 77%

OVERLAY 90%

EXCLUSION 100%

∞ *Create your own personal stock photography collection of textures. Take close-up shots of aged surfaces like peeling paint and rusty metal, concrete sidewalks, leather-backed chairs, linen book covers, canvas, scratched glass, windows dappled with raindrops, and old letters and sheet music.*

∞ *Paint your own textures.*

∞ *Find textures at textureking.com, Flickr sharing groups, nicholev.com, textureonline.com, mayang.com/textures, thecoffeeshopblog.com, inobscuro.com/textures, florabellacollection.blogspot.com and texturevault.net (Be sure to check terms of use.)*

∞ *Apply more than one texture to your photograph. Experiment with Blending Mode applications and Opacity reduction.*

christy's tips for changing
up a texture layer

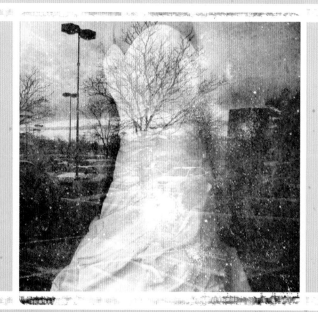

An often overlooked but artistic way to mimic texture in a photo is through reflections. Photographing a reflective window often replicates the dreamy look of layers and ghostly double exposures. This example of a creative window display was shot on my iPhone and reflects the window's surroundings.

WHILE PASSING THE WINDOW OF THIS BRIDAL SHOP, I NOTICED HOW THE REFLECTION OF THE TREES AND FALLING SNOW CREATED AN ETHEREAL SCENE. THE TREES, SNOW, PARKING LOT LIGHTS AND WEDDING DRESS GIVE THE ILLUSION OF LAYERS PLACED ON THE PHOTO WHEN IN REALITY THIS IS A SINGLE SHOT TAKEN WITH A MOBILE PHONE.

GUEST SPOTLIGHT:
TEXTURE/BLENDING MODES

❯ Misty Mawn

Misty Mawn's images were taken with her Nikon D5000
and a macro lens. Using Photoshop Elements, she created
her pieces by layering images. For each layer, she adjusted
the Opacity, Saturation and Brightness levels. Misty also
experimented with Blur and Cooling filters in her work.

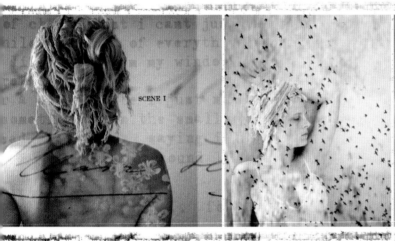

COOLING FILTER
ALTER THE MOOD OF YOUR
PHOTO BY APPLYING A BLUE
COOLING FILTER. **LAYER>NEW
ADJUSTMENT>LAYER>PHOTO FILTER.**

COMBINED IMAGES FOR ATMOSPHERE
CREATE ATMOSPHERE WITH A SECONDARY
IMAGE LAYER. APPLY A BLENDING MODE
TO BETTER COMBINE THE TWO IMAGES.

IMAGE LAYERS
ADD INTEREST TO YOUR SUBJECT BY ADDING ANOTHER IMAGE
LAYER. EXPERIMENT WITH BLENDING MODES.

SEMI-SILHOUETTE EFFECT

bringing a sense of timelessness, drama and meaning to your images

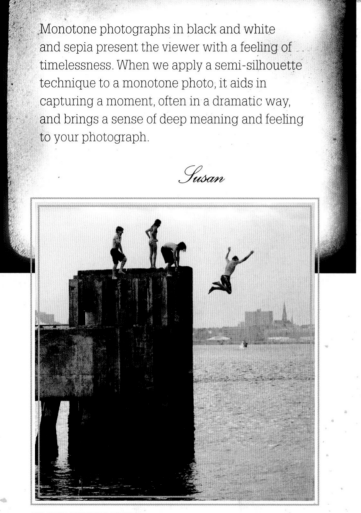

Monotone photographs in black and white and sepia present the viewer with a feeling of timelessness. When we apply a semi-silhouette technique to a monotone photo, it aids in capturing a moment, often in a dramatic way, and brings a sense of deep meaning and feeling to your photograph.

Susan

NO FEAR BY SUSAN TUTTLE

WHAT YOU'LL NEED

DIGITAL MATERIALS

Subject photo

Texture photos

SOURCES FOR PROJECT ARTWORK

Grunge texture in step 5 is from Nicole Van's Chic Vintage Texture set (www.nicholev.com)

Grunge texture in step 6 was created by Christy and is available for download at CreateMixedMedia.com/photo-craft

TECHNICAL SKILLS

Duplicating a file

Removing color

Adjusting Brightness/Contrast

Adjusting Levels

Moving one file into another

Resizing

Adjusting the Blending Mode of a layer

Adjusting the Opacity of a layer

enhance your monotone with a color tint

Go to Enhance> Adjust Color> Color Variations. Experiment until you find a look that appeals to you.

1 **Duplicate your subject photo.**
This will be your working file.

2 **Remove color.**
Desaturate the tones of your photograph by removing all color.

3 **Increase contrast.**
Increase Contrast to +93. This will create a strong distinction between light and dark tones, giving you a semi-silhouette style.

4 **Adjust levels.**
Create further contrast between light and dark tones with the Levels feature. In RGB channel mode, move the black triangle Input Level to +12, thus darkening the black tones.

5 **Add a grunge texture.**
Add texture from Nicole Van's Chic Vintage Texture set to enhance the silhouette. Resize as necessary. Set Blending Mode of this layer to Vivid Light with an Opacity of 55%.

6 **Add further grunge texture.**
To further texturize the piece and bring back some lost details, apply Christy's grunge texture (available for download at CreateMixedMedia.com/photo-craft). Resize as necessary. Set the Blending Mode to Color Dodge with an Opacity of 37%. Save your file.

ALL CRACKED UP

thinking outside the box of the traditional frame

Let's break out of the box a bit with a modern-day twist to classic frames! Display your photos by surrounding them with scrumptiously delicious texture that doubles as a one-of-a-kind work of art. If crackle isn't your thing, you can easily substitute modeling paste and smooth the surface for a look that is a bit more polished and refined.

Christy

WHAT YOU'LL NEED

Cradled wood panel

Crackle paste

Paint scraper

Photo printed on art paper

Acrylic glazing medium

2 colors of acrylic paints (Pull colors from photo, a light and a dark.)

Dictionary page

Glue stick

Baby wipes

Brayer

OPTIONAL

Gel medium, wax paper, heat gun

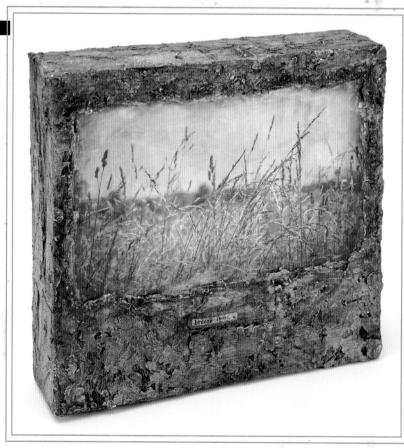

1 Glue and burnish.
Glue your photo to the panel and burnish with a brayer. To avoid damaging the photo, place wax paper over the picture before burnishing. Glue text (from the dictionary page) beneath it.

2 Add crackle paste.
Apply a thick layer of the crackle paste onto the panel, leaving only the photo and text showing. Some surfaces may resist the crackle paste, so once it is completely dry, make sure the crackle paste isn't crumbling off. If it is, brush on a thick coat of gel medium to ensure adhesion. The gel medium should be completely cured before you proceed.

3 Paint.
Mix your lighter color with acrylic glaze to extend the working time of the paint. Brush it over the entire surface—be sure to work it into the crevices. Adding light, thin touches of glaze to the photo itself with a baby wipe will help blend it into its surroundings. Use a heat gun to speed up drying time, if desired.

4 Mix and spread.
Mix equal parts of your dark acrylic paint with the glazing medium. Spread this mixture over the entire surface working it into the cracks.

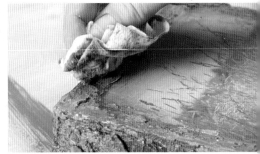

5 Wipe.
While it is still wet, wipe glaze mixture off with a baby wipe to reveal some of the paint beneath it. Continue adding and removing this dark glaze until you are happy with your finished piece.

texture ready

The opportunity for exploration is one of the major draws photography offers. Photographing textures expands upon this idea and becomes an enjoyable modern-day scavenger hunt in which unusual and intricate details, depth, eye-catching patterns and vibrant colors take center stage. These photographs make exquisite stand-alone abstract art or they can be digitally blended with other photographs for a unique way to enhance your work.

There is an art to shaping your vision to hone in on unusual textures for extraordinary abstract art. Practice and experimentation will help you get the feel for which patterns and colors make for a pleasing stand-alone photograph. Look for curves, leading lines and repeating patterns, and take several photos from different angles and at different focal lengths from your subject. Warning: This practice can become incredibly addictive and once you start looking for texture, you'll begin to see them everywhere!

I approach blending textures with other photos differently. I prefer softer, gentler textures with most of my photographs and typically alter my photos to suit that preference. I convert them to grayscale, decrease the contrast and often apply a soft blur to take the edge off. I use digital masking techniques to remove the heaviest texture from my subjects and often adjust the opacity of the texture layer. When I'm out and about shooting for these, I favor a perspective that is either macro close or taken from a distance. Shooting straight on also helps reduce any distortion that might otherwise affect my final image. I find that reflections, patinas and painterly surfaces like old metalwork are the most versatile.

Christy

BOKEH AS AN ABSTRACT PHOTOGRAPH

A MACRO PHOTOGRAPH OF A TREE BRANCH AS AN ABSTRACTION

A PORTION OF A RUSTY GARDEN CONTAINER

AN OLD FADED SIGN ON A CONCRETE WALL

OLD FILM THAT WASN'T PROPERLY EXPOSED MAKES AN EXCELLENT BLENDING TEXTURE

DIRTY WALLS MAKE FOR INTERESTING TEXTURES

WATER TEXTURES ALWAYS LEND THEMSELVES TO MOVEMENT.

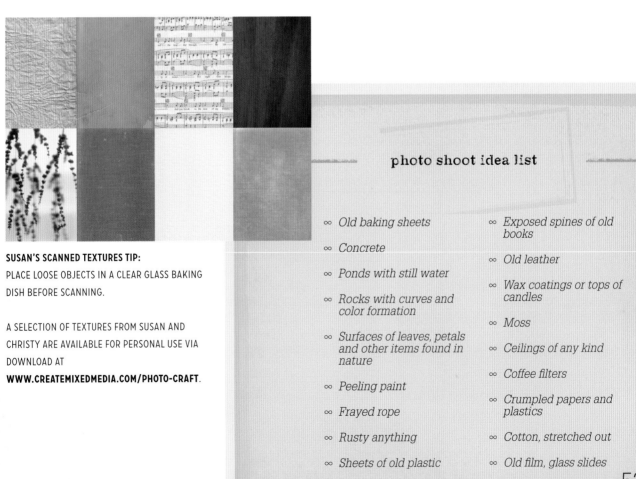

SUSAN'S SCANNED TEXTURES TIP:
PLACE LOOSE OBJECTS IN A CLEAR GLASS BAKING DISH BEFORE SCANNING.

A SELECTION OF TEXTURES FROM SUSAN AND CHRISTY ARE AVAILABLE FOR PERSONAL USE VIA DOWNLOAD AT
WWW.CREATEMIXEDMEDIA.COM/PHOTO-CRAFT.

photo shoot idea list

- ∞ Old baking sheets
- ∞ Concrete
- ∞ Ponds with still water
- ∞ Rocks with curves and color formation
- ∞ Surfaces of leaves, petals and other items found in nature
- ∞ Peeling paint
- ∞ Frayed rope
- ∞ Rusty anything
- ∞ Sheets of old plastic

- ∞ Exposed spines of old books
- ∞ Old leather
- ∞ Wax coatings or tops of candles
- ∞ Moss
- ∞ Ceilings of any kind
- ∞ Coffee filters
- ∞ Crumpled papers and plastics
- ∞ Cotton, stretched out
- ∞ Old film, glass slides

TRANSFORMING PHOTOS INTO ART

3

There is something very satisfying about transforming a cherished photograph into a painting or a sketch. Artists can use both mixed-media products and digital software to create these results. Let us share with you how you can convert your favorite photos into fine art! Create a faux impressionistic painting with a special brush tool in Photoshop, "paint-over" your imagery with PanPastels and make fabulous projects with woodburning, screen printing and watercolor paint-over techniques. For this chapter's Focal Point, we take you on a "still life adventure" that is sure to have you photographing beyond the traditional bowl of fruit.

Susan

USING THE IMPRESSIONIST BRUSH TECHNIQUE AS WELL AS THE DRY BRUSH FILTER.

USING THE IMPRESSIONIST BRUSH TECHNIQUE WITHOUT A FILTER APPLICATION.

susan's notes on brushes and other tools to transform your much loved photos

Experiment with the regular Brush Tool and play with the various types of brush styles. Adjust settings for different effects. Choose your paint colors. Not only will this yield fantastic results, but it can be used as a stepping-stone exercise to practice actual painting techniques without the commitment and mess.

Experiment with applying a variety of filters to your photos to achieve many different types of painting styles. Go to Filter> Filter Gallery. Try filters like Watercolor, Dry Brush, Palette Knife, Paint Daubs and Sponge. You can also try some Brush Stroke filters to replicate crosshatch strokes, ink outlines and more. Go to your local library and take out some books on painting techniques. Refer to them as you paint digitally. Replicate things like brush types, styles of painting and techniques for laying down color like scumbling, drybrush and stippling.

Try printing some of your finished pieces onto canvas paper or watercolor paper, and frame them for display. Or have them made into giclées (printed on stretched canvas). Several online venues provide this service; canvasondemand.com is one to try.

You'll find some great resources for free brushes and filters on the Internet. In addition to painting, brushes are good for stamping (one click of the mouse or push of the graphic tablet pen will make the stamp mark). Many brushes available for download online make excellent stamps.

Be sure to read terms of use before using these resources in your work:

BRUSHES

brushking.eu

obsidiandawn.com

deviantart.com

brusheezy.com/brushes

inobscuro.com/brushes

FILTERS

cybia.co.uk/theworks

FOIL TRANSFERS
no longer is creativity with foil limited to tin hats

When I set out to duplicate old tin-type images, I was foiled (go ahead, groan) time and again. I eventually did replicate the look, but along the way my experimentation brought on this unexpected use for an everyday item. I love when that happens! Using gel-based transfers, an aluminum foil surface and alcohol inks, this technique introduces urban chic to the old masters.

Christy

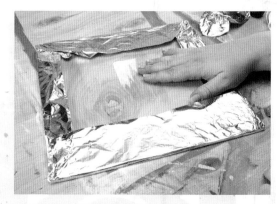

1 Cover surface with foil.
Cut a piece of foil larger than the size of your work surface to comfortably fold around the edges. Think of it as a present to yourself as you wrap the heavy-duty foil around the board and smooth the corners flat.

WHAT YOU'LL NEED

Sturdy surface to work on (I used wood)

Heavy-duty aluminum foil

Gel medium

Brush

Laser-printed photograph

Old credit card, brayer or bone folder

Alcohol inks, variety of colors

Cotton swabs

Alcohol inks blending solution

Awl or ball pen that doesn't work

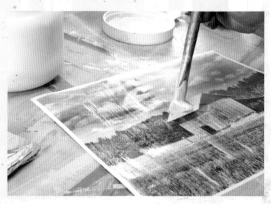

2 Add gel medium.
Generously brush a not-too-thick, not-too-thin coat of gel medium over the front of the printed image. Be sure to cover it entirely.

3 Burnish the photo.
While the medium is still wet, place the photo face-down onto the foil and burnish it with an old credit card, bone folder or brayer.

4 Test.
Wait three to five minutes and pull up a corner to see if it has transferred. If it hasn't, burnish a bit more, then slowly peel up the paper again. Use your fingers or a sponge to rub off excess paper.

5 Modify.
Scrape and rub the edges of the photo while it's wet for a ragged look. You can also scrape away parts of the image with a sharp object and embed words, doodles or anything else your imagination can dream up.

6 Begin painting.
Tear off a small piece of foil to use as a palette. Add a drop or two of your first color and dip your cotton swab into it. The cotton swab will act as a paintbrush; use it to apply the alcohol ink. Use clean swabs for each color. If you have an aversion to coloring outside the lines, use blending solution on a clean cotton swab to remove color from an area. Depending on the color, it may take a few dabs

7 Continue.
Blending your colors is easy with the cotton swabs. Vary your pressure to remove color in one area and blend it with the surrounding colors. Experiment with dropping the ink directly onto the piece for a totally different look. Repeat the process with the remaining colors until you can't help but to pat yourself on the back for a job well done.

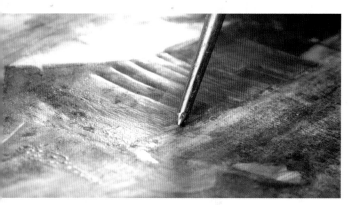

8 Prep for highlights.
Trace the areas you'd like to highlight with an awl or old pen. Keep in mind, these areas will be slightly raised upon the project's completion.

9 Finish.
Unwrap the foil. Flip it over and retrace the lines you etched. This will add an embossed, dimensional look to your piece.

tips

∞ *Crumple the foil before you attach it to the surface for an entirely different look. Experiment with creases and the natural texture foil lends to the project.*

∞ *Mount the image to wood, canvas or even a book cover, or integrate it into a larger work of art.*

∞ *Black-and-white photography really pops on a metallic surface. Skip the painting or use the metallic alcohol inks for a modern urban feel.*

∞ *As with any transfer, remember to mirror your image before printing it if it has text or if you want the photo to appear exactly as it is.*

MODERN COUNTRY BY CHRISTY HYDECK

Here is an easy digital recipe to give faux tintype coloring to your images, minus the pretty frames that traditionally encapsulate them.

FAUX TINTYPE RECIPE

1. Desaturate the color of your photo:

> *Enhance>Adjust Color>Remove Color.*

2. Alter the color to give it a washed-out sepia tone (characteristic of some of the traditional tintypes):

> *Enhance>Adjust Color> Color Variations (Select Shadows, click twice on Decrease Blue and click once on Increase Red.)*

3. Increase contrast:

> *Enhance>Adjust Lighting>Brightness/Contrast (I enhanced the Contrast to +20.)*

4. Add a film grain:

> *Filter>Artistic>film grain with the following settings:*
>
> *Grain: 1*
>
> *Highlight Area: 9*
>
> *Intensity: 0*

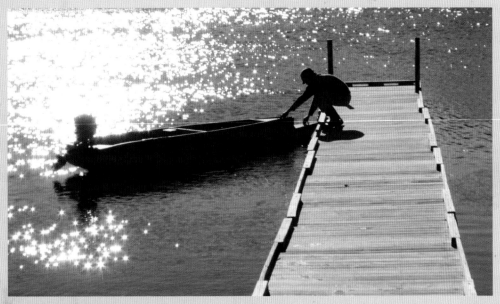

SOLITUDE BY SUSAN TUTTLE

PANPASTELS PAINTOVER

cheating that won't land you in trouble

Whether you are a seasoned pro or an absolute beginner, PanPastels are an awesome medium for you to explore. They can be applied in thin, sheer coats or put on thicker for a more opaque look. PanPastels are amazingly forgiving and can be erased prior to sealing them. The colors are spectacularly vivid and can cover a large area in a very short amount of time. I can brilliantly blend and shade an entire 8.5" × 11" (20cm × 28cm) piece in well under an hour.

PanPastels are an investment, but they will go a long, long way. It takes very little of the medium to achieve intense color. Just a couple of light swipes over the pan will pick up all you need. Grab a test sheet of paper and swipe color over it a few times to get the feel of it.

For this project, we are going to take a photograph converted to black and white and apply PanPastels directly over it to create what looks like an original painting. When applied in thin coats, the highlights and shadows in your photo will show through a bit, taking the guesswork out of where to put the pastels.

Christy

WHAT YOU'LL NEED

PanPastels

Image printed on art paper (The photo used here was created by Christy and is available for download at Create-MixedMedia.com/photo-craft.)

Brushes, applicators (Sofft makes good ones)

Colored pencils

Eraser

Fixative to seal

darks recede

When shading your image, the most important thing to remember is that dark recedes and light moves forward. Therefore, white highlights should go where you want something to appear round (like the edges of the petal), and darker tones go where the item is set back, (like the center of the flower).

1 Prepare and begin.
Determine which elements of your photo you don't want in the final product. Choose two shades of the PanPastels to blend, and use them to block out your background. To apply a thicker coat, allow the layers to build up until the elements you didn't want have disappeared. It's OK if the color overlaps other elements because we can erase it or build color layers over it later.

2 Start.
Dab the lightest shade of yellow in the center of the flowers. Don't worry about blending yet; we'll take care of that later.

3 Continue.
Dab on color in the middle of the petals with an orange-yellow that is a shade or two darker than the initial color.

4 Add red.
Dab a dot of red along each of the petals' edges. Using a clean applicator, lightly rub the tip over the colors to smear and blend them. Embrace imperfections as they make the flowers look more realistic.

5 Highlight.
Add cream highlights by dabbing in the middle of a flower petal and along the very edges. Blend as you apply.

6 Work on the leaves.
Shade most of the leaves with your lightest green. Use a thin coat so the detail shows through a bit. Then add a darker green to the middle of the leaves, and on some edges. Blend as before. Shade the other parts of your photo with desired colors.

7 Lighten.
With an eraser, lighten the colors where desired. I chose to bring back some of the detail I had covered. Using the gray shades, add shadows, blending while you apply, where applicable.

8 Finish.
Add definition as needed with colored pencils. Do this by sketching over the photo in shades similar to the pastel colors. Seal with the fixative of your choosing.

RUSTIC GARDEN BY CHRISTY HYDECK

GUEST SPOTLIGHT: MIXED MEDIA

➤ Pam Carriker

To create this portrait of my rescued Jack Russell terrier, I used an extremely matte medium (MMA) to glue a copy of a photo onto a hard substrate. By painting out the background with Matisse Background Colors (colored gesso-like paint) it's easy to focus attention on the main image. The porous texture of both the background color and MMA makes using even watercolors easy. Graphite in liquid form (Sketching Ink by Derivan) allows for soft shading with a blending stump and turns the photo into a drawing. Layering paint, both acrylic and watercolor, with graphite creates a soft look. Use Permanent Sketching Ink for the eyes, nose and deep shadows, and then burnish it to a lovely graphite sheen.

MATERIALS USED

Hardboard artist panel

Pam Carriker Mixed Media Adhesive (MMA—Matisse Derivan)

Pam Carriker Sketching Ink, Rewettable (liquid graphite—Matisse Derivan)

Pam Carriker Sketching Ink, Permanent (liquid graphite—Matisse Derivan)

Acrylic paints

Blending stump

Acrylic paint medium

Matisse Background Colors (colored gesso)

Soft cloth

Paintbrushes

Graphite pencil

RESCUE ME BY PAM CARRIKER

HOW TO GET THIS EFFECT

Print out a black-and-white copy of the photo (sized to fit your substrate) onto copy paper. Adhere to the substrate with MMA. Apply MMA over the top of the photo as well and let dry. Paint out the photo background using Matisse Background Colors. Apply rewettable sketching ink to all shaded areas using a wet brush. Let dry and blend with a blending stump. Use acrylic paint mixed with acrylic paint medium and water to colorize the photo. Use permanent sketching ink to deepen shaded areas. Let dry and burnish to a sheen with a soft cloth. Add highlights using paint, and finish with sketchy lines drawn with a graphite pencil.

CREATE A REALISTIC-LOOKING WATERCOLOR PAINTING

in just three easy steps!

I love paint! As a digital artist and photographer I spend most of my time working at my computer with a graphics tablet in hand. I do love my little digital cubby of a studio tucked into the corner of my bright and sunny bedroom, but I long to spend more time in my art studio downstairs, feeling a brush between my fingers, smelling the scent of wet paint, applying washes of color to fresh canvas. With this project I can have the best of both worlds. Join me and let's get some paint on our fingers!

Susan

1 Duplicate subject photo.
Duplicate your subject photo. This will be your working file.

WHAT YOU'LL NEED

DIGITAL AND ACTUAL MATERIALS

Subject photo

Watercolor paint

Soft bristle or watercolor paintbrushes

Container of water

Soft cloth or paper towel

Watercolor paper

Printer

TECHNICAL SKILLS

Duplicating a file

Applying a Charcoal filter

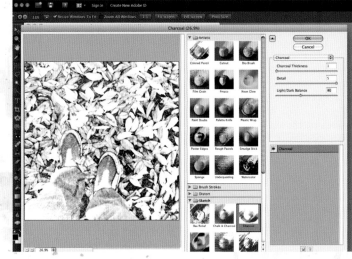

2 Apply Charcoal filter and Save File.
Apply the Charcoal filter to turn your photograph into a sketch. Play with the levels until you are satisfied with the results. I used the following settings:

Charcoal Thickness: 1

Detail: 5

Light/Dark Balance: 40

Save file.

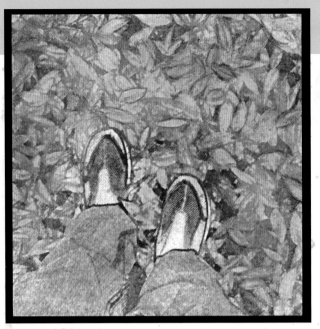

3 **Apply watercolor paint.**
Print your photo onto watercolor paper and brush on washes of watercolor paint over the existing marks and negative spaces.

ANOTHER WATERCOLOR PAINTING EXAMPLE: **OUR HOUSE** BY SUSAN TUTTLE

tips · prompts · variations

∞ *You can paint the same colors present in the original photo or change them as you wish.*

∞ *Experiment with the Charcoal filter settings. My lines are fairly harsh, but you may want the sketch to be lighter so it does not show through in the finished product. It all depends on the look you want.*

∞ *Try out different filters from the Filter Gallery (Filter> Filter Gallery) and experiment with painting over your printed results with a variety of different paints like acrylic, gouache or oil. You might try applying pigment with colored pencils, oil pastel sticks or chalks.*

YOU CAN ALSO TURN YOUR FAVORITE PHOTOS INTO "PAINTINGS" WITH THE ARTISTA HAIKU CELLPHONE APP. FOR MORE INFORMATION ON APPS, VISIT ONLINE RESOURCES SECTION AT THE BACK OF THIS BOOK.

WOODBURNING AND WATERCOLORS
brought to you in part by the letter W

As wild, wonderful and worthwhile as this project can be, I willingly offer up a disclaimer here. I am not a woodburning expert. I'm a whimsical artist with a wicked affection for wooing different mediums. I become giddy at all the possible ways one can alter an image. While I wholeheartedly encourage you to try your hand at woodburning, please keep in mind this is simply my personal process and simple it is! If you get the wide-eyed, woodburning bug after trying it, you may wish to make the effort to learn more about the many proper and wondrous ways of working with it.

Note: Before you can begin woodburning, you will need to transfer your image. To do so, place a piece of transfer paper on the wood. Gently set your printed image on top of it. Use a pencil to trace all of the desired details and shading. Remove the paper and image once complete.

Christy

WHAT YOU'LL NEED

Stain-grade wood

Image printed on regular paper

Transfer paper (sized to your printed image) or charcoal

Pencil

Woodburning tool

Sandpaper

Watercolor pencils

Water

Baby wipes

Brush

Glazing medium

Diamond glaze/glue

Embellishments

Dremel tool or other tools to distress

Workable fixative

SHE SHOOTS LIKE A GIRL BY CHRISTY HYDECK

1 **Heat up your woodburning tool.**
Begin to trace the image using slow, steady pressure with the woodburning tool. Move your arm, not your wrist, to get steadier lines.

2 **Keep your tool clean.**
Rub the tip of the woodburning tool over a scrap piece of sandpaper every few minutes to keep it clean.

3 **Add color.**
Add color to the background with watercolor pencils. Wet a paintbrush with water and gently paint over the colored parts. For stronger, bolder colors repeat until the desired color intensity has been achieved.

4 **Seal.**
Once dry, brush a thin coat of glazing medium over the color to seal it.

5 **Distress.**
Distress the edges of your wood substrate with a Dremel tool. Follow the manufacturer's instructions and experiment with different attachments for different effects.

6 **Sparkle and Seal.**
Add some sparkle by mixing diamond glaze with glitter and brushing it on. Add buttons, beads or anything you like to enhance your finished piece. To ensure longevity, seal your piece with workable fixative. Do this in a well-ventilated area.

tips

∞ *Practice, practice, practice basic movements using the woodburning tool on a scrap of wood. Draw circles, curved lines, straight lines and then burn them. This will help you get the feel of how the tool works on the wood of your choosing.*

∞ *No transfer paper? No problem. Just rub a solid coat of charcoal over the back of your printed image, and you have your own handmade (albeit slightly messier) transfer paper.*

➤ FOCAL POINT

Setting up still-life compositions to photograph—
of either objects found in nature or ones made by
human hands—brings much artistic possibility
and pleasure. Enjoy creating unique and amusing
still-life photo shoots, and perhaps try some of the
following ideas.

Susan

- ∞ The proverbial fruit in a bowl
- ∞ Flowers with interesting colors and textures
 placed in an attractive vase (have fun making
 an arrangement)
- ∞ Stacked river stones
- ∞ Drinking glasses
- ∞ Vintage books
- ∞ Antique luggage
- ∞ Costume jewelry
- ∞ Collections of objects (buttons, keys, pushpins,
 art supplies, figurines, knitting needles,
 vintage cameras, wine corks, coins, flora)
- ∞ Sea glass
- ∞ Sliced fruit and knife on a cutting board
- ∞ Baked goods
- ∞ Pretty journal and fountain pen
- ∞ Breakfast, lunch or dinner
- ∞ Candy
- ∞ Ironing board, iron and garment
- ∞ Wine bottle opener
- ∞ Teapot

THE SWEET LIFE BY SUSAN TUTTLE
YOUR STILL-LIFE SHOULD BE COMPOSED AGAINST A SPARSE, CLEAN BACKGROUND
TO ALLOW YOUR SUBJECT TO BECOME THE FOCAL POINT.

tips

- ∞ *Try shooting from a variety of angles.*
- ∞ *Manipulate your still life with any of the
 digital photo manipulation techniques in
 this book.*

➤ For more information on apps, please visit
the **Online Resources section** at the back
of this book.

SUSAN'S STILL-LIFE MONTAGE

susan's field trips + photo shoot idea list

Visit brick and mortar and online art galleries and exhibits for ideas on still-life subject matter. Look at paintings as well as photographs. You can even try a Google or Flickr image search for "still life."

It is very easy to take still-life photos throughout your day using your cell phone cam. Your cell phone, a lightweight item you most likely take wherever you go, can be used as a tool to bring art and meaning into your life at any given moment. If you have an iPhone or iPod Touch, you can run your images through a variety of photo apps to achieve interesting results (there are some apps available for Androids and Blackberries too). Or you can give your still-life photo the look of an oil painting by putting it through Corel's Paint it! Now (as seen in the photo of the coffee mug in the montage).

christy's field trips + photo shoot idea list

Create foodscapes! When I first discovered Carl Warner (www.carlwarner.com), I thought I was viewing some amazing hand-painted landscapes. Looks can be deceiving! It turns out he creates these incredibly realistic landscapes entirely made of food. He has used salmon as a sea, broccoli as trees, potatoes as mountains and he has made houses of cheese. This is one of those things you have to see to believe; words don't do it justice. Once you pick your jaw up off the floor, brainstorm ideas to create your very own foodscapes!

For more great field trip and photo shoot ideas from Christy, check out www.createmixedmedia.com/photo-craft.

69

TIMELESS PHOTOGRAPHIC TECHNIQUES

4

This chapter demonstrates how to replicate timeless photographic styles through both digital and mixed-media techniques. Learn how to create vignettes to frame your subjects, add dreamy and hazy looks with digital fill layers and tissue paper, make a faux Polaroid in just a few easy steps, and follow a cross-processed recipe that's Betty Crocker easy. You will also learn how to shoot through a variety of different materials and homemade filters, to give your photographs extra special pizazz! This chapter can be defined in one word—*fun*!

Susan

LENSBABY

Have you ever wondered how photographers achieve interesting blur effects and dreamy, soft and ethereal looks in their photos? Are you ready to dive in and create your own photos in this very same vein? I am willing to bet you answered yes to at least one of those questions, and I am ready to help. A unique line of products for your digital SLR camera that give your photographs these special effects— introducing Lensbaby! With tilt-shift and selective focus capabilities and unique effects that are characteristic of a plastic-lens look, Lensbaby offers lots of options to suit your needs and tastes, and they make the process fun to explore. The Lensbaby system differs from standard camera lenses. You start by selecting a lens body and then choose from a variety of optics which slip inside the body of the lens and produce their own unique effects. You can add some accessories into the mix for further special effects.

Christy and I have experimented with Lensbaby's Creative Effects System Kit, which comes with the Composer Pro lens body, and a variety of optics including pinhole/zone plate, plastic, single glass and double glass. Accessories include a Creative Aperture Kit (for producing shapes of light in your photos), Wide Angle/Telephoto Kit, and a Macro Kit. Let's take a look at some of the photos that Christy and I took with our Lensbaby kits.

SOL BY SUSAN TUTTLE

THE SINGLE GLASS OPTIC GIVES YOU A FOCUSED CENTER AND A DREAMY, ETHEREAL BLUR TO THE OTHER AREAS OF THE PHOTO. THIS LENS IS GREAT FOR PORTRAITURE AND MONOCHROME IMAGES. IN MY EXAMPLE, I COUPLED THE SINGLE GLASS OPTIC WITH THE HEART SHAPE FROM THE CREATIVE APERTURE KIT. IF YOU LOOK CLOSELY, YOU WILL SEE THAT THE LITTLE POINTS OF BLUE LIGHT BOUNCING OFF OF THE WAVES ARE IN THE SHAPES OF DELICATE WHIMSICAL HEARTS.

SAYS CHRISTY: LENSBABY'S INNOVATIVE TECHNOLOGY EMBRACES MOVEMENT, PUSHES THE LIMITS OF CREATIVITY AND TRULY ALLOWS YOU TO SEE YOUR SURROUNDINGS IN A NEW WAY. THE SENSE OF MOTION, THE LULL OF THE IMAGINED WINDS, THE DREAMY AND OFTEN ETHEREAL WORLDS THAT COLLIDE WITHIN THE FRAME CONTINUALLY ASTOUND ME! (ABOVE PHOTOS BY CHRISTY HYDECK.)

THE DOUBLE GLASS OPTIC GIVES YOU A SHARP FOCAL CENTER (CALLED A SWEET SPOT) AND APPLIES A BLURRED EFFECT TO THE SURROUNDING AREAS OF THE PHOTOGRAPH.

THE PINHOLE/ZONE PLATE OPTIC IS ONE OF THE DREAMIEST LENSBABY OPTICS. YOU GET GLOWING, SOFT PHOTOS WITH SHARPER EDGES. I LIKE TO USE THIS OPTIC IN SETTINGS IN WHICH THERE IS A LOT OF BRIGHT LIGHT. BUT YOU CAN ALSO USE IT IN A DARKER SETTING IN WHICH AN OBJECT OR PERSON IS BATHED IN A RAY OF LIGHT—THIS CREATES A GHOSTLY, INTROSPECTIVE FLAVOR.

THE PLASTIC OPTIC IS PERFECT FOR TOY CAMERA FANS! THIS IS BY FAR LENSBABY'S SOFTEST OPTIC AND CAN PRODUCE INTERESTING COLORING EFFECTS ALONG EDGES OF ELEMENTS IN THE PHOTO (KNOWN AS CHROMATIC ABERRATION). YOU CAN SEE THIS TYPE OF DISTORTION ALONG THE GRIDS OF THE WINDOWPANE IN MY PHOTO EXAMPLE.

(ABOVE PHOTOS BY SUSAN TUTTLE)

VIGNETTES BY HAND: CHARCOAL + SANDPAPER

because even your eyes need to rest sometimes

Think of vignettes as your new best friends. They exist to help you create focal points and set the mood within your images. A vignette is a simple but powerful tool that naturally pulls the eye of the viewer to the middle of the photograph. Less is typically more here, and the subtle shift can substantially elevate the intensity of an image.

Nothing quite changes the mood of a photograph like a vignette can. Going a bit overboard can create an intense and darkly dramatic image—try adding a dark or black vignette around the edges of your photo. Alternatively, try a lighter and brighter method by fading out to white. For the funky at heart, there is no reason why you can't experiment with colors to find a style that is uniquely yours and yours alone.

Let's jump-start your soon-to-be vignette addiction with the techniques that follow.

Christy

" FLYING SOLO" BY CHRISTY HYDECK

WHAT YOU'LL NEED

CHARCOAL VIGNETTES

Charcoal, any kind

Photograph printed on watercolor paper or another porous paper

Blending stump

SANDPAPER VIGNETTES

Photo printed on glossy paper

Sandpaper the size of a fingertip or two

"A LEISURELY GRAZE" BY CHRISTY HYDECK

➤ Charcoal Vignettes

This technique offers the artist the most control.

1 Sketch.
Roughly sketch around the edges of the photo with charcoal. As you work, be sure to round the corners off for a softer edge.

2 Blend and soften.
Use the blending stump to feather out the charcoal and soften the lines. Repeat until you have the desired look.

➤ Sandpaper Vignettes

I find this to be the most fun and often most unpredictable method of creating vignettes by hand.

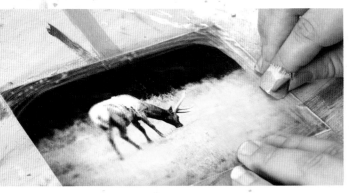

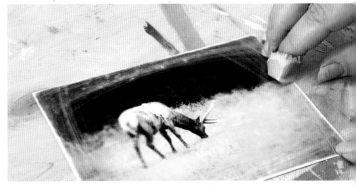

1 Start on the outside.
Wrap the sandpaper around your finger and use the folded edge to rub away the outermost edges.

2 Work inward.
With a lighter touch, work the sandpaper in toward the center, removing pressure as you get farther in. Repeat until you have the desired look.

tips

∞ The Faux Plaster Wall Texture in Chapter 3 is another fun vignette technique.

∞ Try creating different kinds of vignettes with chalks, watercolor pencils and crayons, glazes, Pam Carriker's sketch ink, acrylic inks and PanPastels.

DREAMY PHOTO FRAME
creating a white vignette with the brush tool

A vignette is a wonderful way to frame your image, draw attention to and enhance subject matter and give your photo a unique, artistic flair. I decided to venture a bit off the beaten path, veering away from the classic black vignette, and instead will demonstrate how to render a dreamy white one. You will notice that the original image utilizes a linen book-cover texture. This texture is also available for download at www.createmixedmedia.com/photo-craft.

Susan

ON THE COUNT OF THREE BY SUSAN TUTTLE
A WHITE VIGNETTE ADDS A LIGHT HEARTED, DREAMY EFFECT.

WHAT YOU'LL NEED

DIGITAL MATERIALS

Subject photo

TECHNICAL SKILLS

Duplicating a file

Creating a New Layer

Feathering

Selecting a foreground/background color

USING TOOLS

Rectangular Marquee tool

Brush Tool

Eraser Tool

1 Duplicate the file.
Duplicate your subject photo. This will be your working file.

2 Create a New Layer and select area to be framed.

Create a New Layer and with the Rectangular Marquee Tool select the focal area that you wish to be framed by the vignette effect.

3 Feather selection.

Feather your selection (I used a Feather Radius of 150) and go to **Select>Inverse**, which will select the area to which you wish to apply the vignette.

4 Apply vignette with the Brush Tool.

Select white paint and a Soft Round Brush from the Default Brushes Palette. Size brush as necessary, set brush mode to Normal and reduce the Opacity to about 37%. Gradually paint on layers of pigment. Your paint will mostly stay confined to the selected area of this new layer, so don't worry about being overly neat.

Use the Eraser Tool to erase any unwanted vignette pixels. I set my Eraser Tool to an Opacity of 25%.

Save File.

tips · prompts · variations

∞ *Photos that work well for this technique include ones that include an obvious focal point, generally in the center of the photograph. The vignette around the focal point will draw the viewer's eye in to your subject and enhance the compositional and emotional value of your image.*

∞ *When you put a vignette on its own layer, you can resize and rotate the layer as needed.*

∞ *Apply black paint instead of white to create your brushed-on vignette effect.*

∞ *You can find vignette textures from stock photography sites like shutterstock.com, bigstock.com and iStockphoto.com.*

∞ *Several iPhoneography apps have vignetting filters (for iPhone and iTouch4): iDarkroom, FocalLab, TiltShiftGen, PictureShow, CameraBag, Noir Photo, Magic Hour, BlurFX and FX Photo Studio).*

VIGNETTE IPHONEOGRAPHY MONTAGE

CROSS PROCESSED
a digital darkroom recipe

Cross processing, often referred to as Xpro, is a technique in which color film or slide film is processed in a chemical solution that is made for developing a different type of film. Many photographers in the 1960s and '70s accidentally discovered this method in their darkrooms, and the style became popular in advertising and rock band photography in the '70s. These types of photos usually have high contrast and unnatural color, often with exaggerated tones of blue, green and yellow. In the late 1980s and early '90s, as photographers began to create more clear and perfect images, the lomography (often referred to as lomo-fi or lomo photography) trend emerged in direct opposition to these more crisp images and once again began to utilize and make popular cross processing techniques. Examples of lomo-fi equipment include plastic, toy, fisheye and pinhole cameras. Vintage cameras like the Holga and Diana are specific types of lomography cameras. Recently this style has gained retro popularity status in digital photo manipulation, iPhoneography applications and cinematography. Creating your own cross-processed effect in the digital darkroom is easier than you think, requiring just a few tweaks of Levels and Contrast.

Susan

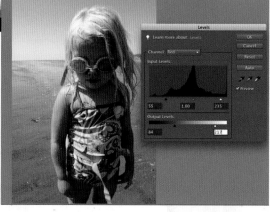

WHAT YOU'LL NEED

DIGITAL MATERIALS
Subject photo

TECHNICAL SKILLS
Duplicating a file

Adjusting Levels

Adjusting Brightness/Contrast

USING TOOLS
Crop Tool

1 Adjust the Red channel.
Open your subject photo and duplicate it. This will be your working file. Adjust Levels. Start with the Red channel (select Red from the channel pull-down menu).

Input: black point: 55; white point: 235

Output: black point: 84; white point: 217

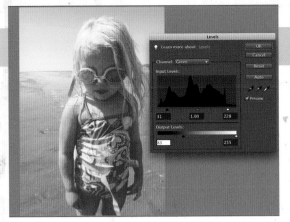

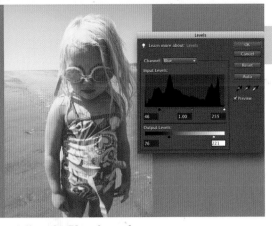

2 Adjust the Green channel.
Repeat for the Green channel.
Input: black point: 31; white point: 228
Output: black point: 83; white point: 255

3 Adjust the Blue channel.
Repeat for the Blue channel.
Input: black point: 46; white point: 255
Output: black point: 76; white point: 221

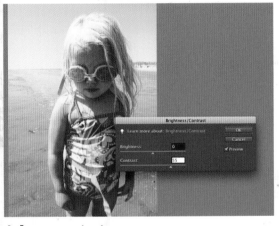

4 Increase contrast.
Up the Contrast level to 55.
Save File.

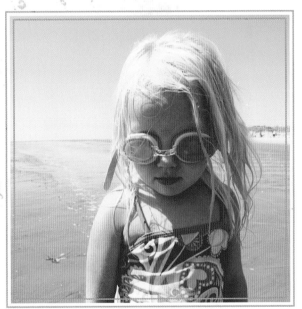

5 Finish.
Crop your photo with the Crop tool if desired. (At the last minute, I decided that cropping the photo to make it a close-up improved the composition.)

tips · prompts · variations

∞ If you have Photoshop Creative Suite, you can also manipulate each RGB channel through the Curves function. Elements does not have this capability, so use the Levels function instead to achieve similar results.

∞ Explore Flickr for examples of cross-processed photography. You'll get great tips on what types of photos work well and ideas for tweaking this recipe to achieve other results.

∞ You'll find suggestions for specific cross process apps in the Online Resources page in the back of this book.

POLAROIDMANIA

replicate the perfect polaroid over and over and never again break your bank purchasing voluminous amounts of highly expensive vintage polaroid film on eBay

When I was nine, my friend Stacey got her first camera—a Polaroid! We spent hours photographing everything from each other to the little people who inhabited her dollhouse. There seemed to be an endless supply of film as we clicked away, enjoying the process. I recall the sound and sight of a photo being taken and released through the little door in the front, all green and hazy. We'd hide it away from the light and wait patiently for the picture to develop.

Today vintage polaroid film costs more than a pretty penny, and a camera that was never intended to provide interesting, arty results is one of the most popular retro cameras, with yields that are even considered to be a legitimate art form. In this exercise you will learn how to create a Polaroid replica–without breaking the bank. So go ahead: Shoot away like you did when you were a kid, without a care in the world. Just enjoy the process!

Susan

1971 BY SUSAN TUTTLE

WHAT YOU'LL NEED

DIGITAL MATERIALS

Subject photo

Photo of Polaroid frame (available as a download at CreateMixedMedia.com/photo-craft)

TECHNICAL SKILLS

Duplicating a file

Adjusting Curves

Applying the Gaussian Blur filter

Applying the Add Noise filter

Adding a Solid Color Fill Layer

Adjusting Levels

Feathering

Adjusting the Blending Mode of a layer

Adjusting the Opacity of a layer

Moving a file into another

Resizing

Arranging a layer

USING TOOLS

Marquee Tool

Crop Tool

1 Duplicate the file.
Duplicate the subject photo. This will be your working file.

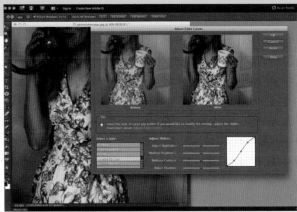

2 Adjust Curves.
Increase contrast by adjusting Curves. Select Increase Contrast for the style.

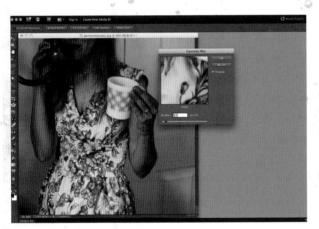

3 Add a Gaussian Blur filter.
Input: black point: 46; white point: 255

Output: black point: 76; white point: 221

4 Add Noise.
Up the contrast level to 55.

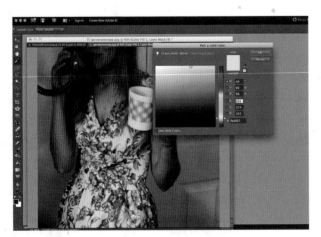

5 Add two Solid Color Fills.
Add a school bus yellow fill. I used color #fbe066 and set it to a Multiply Blending Mode at 13% Opacity and aqua fill #91e3e3 with a Multiply Blending Mode at 31% Opacity.

6 Adjust Levels.

To impose the Levels change to your working file, you will first need to merge layers.

RGB Channel: Set the Output white point triangle icon to 225.

Red Channel: Set the Output black point triangle icon to 45 and the Output white point triangle icon to 237.

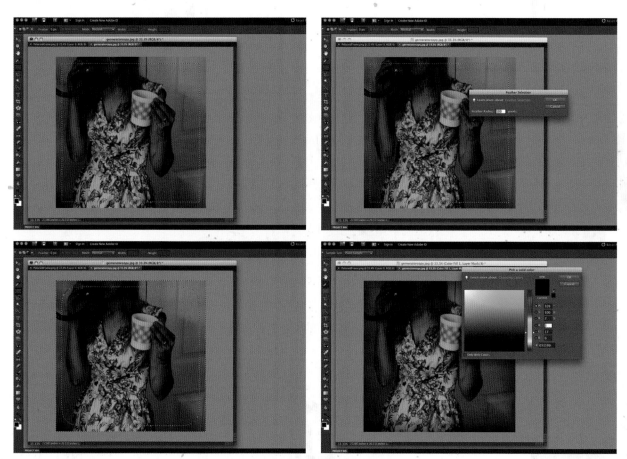

7 Add a vignette.

Use the Marquee Tool to select the majority of your photo, leaving a small edge all around. Feather this selection to a Radius of 100. Go to **Select>Inverse** and fill this area with a Solid Color Fill (#031200) set to Multiply Blending Mode at 45% Opacity.

Save File.

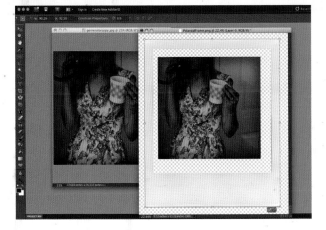

8 Add a Polaroid frame and save file.

Merge layers again. Open the Polaroid frame file and move your working file into it (this frame is available for download at: CreateMixedMedia.com/photo-craft). Adjust the photo's position in the Polaroid opening. If the photo is too small, make the Polaroid frame layer smaller, as enlarging the photo will reduce its quality. If you need to move the photo behind the frame, arrange the layers. Crop out the transparent background on the outer edges of the frame, if needed.

Save file.

tips · prompts · variations

∞ *You can download a free Polaroid app that will turn any photo into a Polaroid replica: www.polaroid.net.*

∞ *Several iPhone/iTouch apps can replicate the Polaroid look, too, including Lo-Mob.*

LO-MOB IPHONEOGRAPHY APP MONTAGE

➤ For more information on Apps, visit the **Online Resources** section at the back of this book.

Perhaps it's the nostalgic sound of the Polaroid camera ejecting film. Maybe it's my need for semi-instant gratification or that driving force inside me that seeks to stumble upon happy accidents. Whatever the reason and despite the investment, I still splurge on instant film at least once a year. Do yourself a favor and splurge every once in a while on this unique product too. Your retro self will thank you.

A QUIET RUSTLING BY CHRISTY HYDECK

tip

To the delight of Polaroid devotees around the world, The Impossible Project (www.the-impossible-project. com) resurrected the defunct Polaroid film and began producing instant film for the public to purchase. Within 24 hours of taking a photo, the film can be freed from its backing and with the help of a hair dryer, the positive upper sheet of film becomes a transparency you can use in your mixed-media art. Full instructions are available on the website.

THE TREES SET HER SOUL ON FIRE BY CHRISTY HYDECK

INFINITELY SMALL BY CHRISTY HYDECK

CHANGING THE MOOD OF YOUR PHOTO

applying a solid color fill layer

It's fun to change the overall color tone of your photograph. Perhaps you'd like to make the sky a richer blue, add a golden glow to your scene or give your image a retro appearance. This process is made fun and easy with the application of a Solid Color Fill Layer.

Susan

WHAT YOU'LL NEED

DIGITAL MATERIALS

Subject photo

TECHNICAL SKILLS

Duplicating a file

Adding a Solid Color Fill Layer

Selecting a foreground/background color

Adjusting the Blending Mode of a layer

Adjusting the Opacity of a layer

I TRIED OUT DIFFERENT FILL COLORS (BOTH WARM AND COOL TONES) AND MANIPULATED THEM WITH BLENDING MODES AND OPACITY REDUCTION:

YELLOW (F5E355): MULTIPLY BLENDING MODE, OPACITY 36%

BROWN (916C18): OVERLAY, 64%

DEEP BLUE (2529BF): OVERLAY, 38%

PINK (F5B3F3): COLOR BURN, 58%

1 Duplicate the file.

Duplicate your subject photo. This will be your working file.

2 Select a color and Blending Mode.

Try aqua (#03cbcb) or another color for the fill layer. I decided to apply the Overlay Blending Mode and reduced the layer's Opacity to 39% so the color was not too intense.

Save file.

VINTAGE HAZE

where texture meets muted tones in just a few minutes

A few years back, as an investment in myself, I made the commitment to create daily. Sometimes that means creating a large painting, other times it means redecorating. The idea is to infuse my life with creativity for the simple joy of it (the mental health benefits are a bonus!). Much like yours, I'm sure, my life is often overscheduled, and that makes honoring that promise difficult at times. So when I stumble across happy, creative accidents that don't eat up a huge chunk of time, I get a bit giddy. This project just so happens to be one of those discoveries. It is pretty as is, or it can serve to be part of a larger piece altogether. This technique works best with vibrant photos and/or high contrast images.

Christy

WHAT YOU'LL NEED

Wood, sanded, or other sturdy surface to work on

White tissue paper

Paintbrush

Gel medium

Brayer

Glossy photo

Wax paper

Sandpaper, any grit

tips

∞ Try colored tissue, sewing patterns and other thin papers for additional variations.

∞ Substitute clear gesso for the gel medium for the final coat, and sketch or paint over the top of the hazy photograph.

∞ Turn this piece into a journal cover by drilling holes on one side. Or add holes at the top and string ribbon through it for hanging.

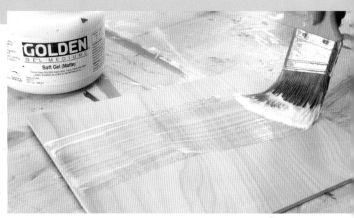

1 **Add tooth.**
Give the back of the photo some tooth for the adhesive to grab onto by sanding it. Wipe off the debris so you have a clean surface to work with.

2 **Apply gel medium.**
Quickly apply a generous coat of gel medium to the wood. Cover it thoroughly.

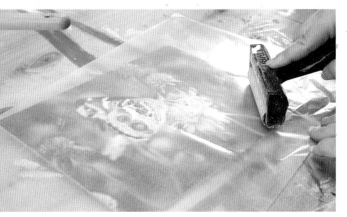

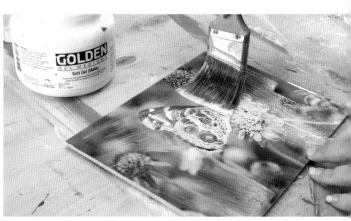

3 **Protect.**
Place the back of the photo onto the wood, then place a protective surface like wax paper over the photo. Use a brayer to burnish the photo to the wood. Remove the wax paper and allow the piece to dry.

4 **Add another coat of gel medium.**
Quickly brush a thin, wet coat of gel medium onto the photo. Try to keep your brushstrokes in even, consistent lines, as they may show.

5 **Finish.**
While the gel medium is still wet, gently lay tissue paper over the entire photo. Using a light touch, smooth it out with your hand. Be careful not to rub too hard or fast, as the tissue paper can tear. Once it has dried, brush a final coat of gel medium over the top, and if necessary, sand the edges to make the tissue paper is flush with the edges of the board.

➤ FOCAL POINT

veiled shooting through found materials

The act of placing something between your lens and your subject is an unconventional but totally exciting and enlightening experience. It is a way to fuel your creative spirit, sharpen your skills and learn methods of alternative imagery that can yield spontaneously delightful results. As each material and each shot taken acts differently, you are bound to create some unique photographs that can't be replicated.

For items that are soft or pliable, I typically cut a piece bigger than my lens, wrap it around the sides and use a rubber band to secure it. I hold materials that are solid and can't be bent in front of my lens using my nondominant hand. I experiment with my surroundings, seeing how the different angles of light affect the material I am shooting through. I am constantly amazed at the many effects a single material can produce.

I shot a series of photos depicting the same landscape as seen through the materials listed below. I hope these images spark a desire to release your inhibitions and freely play with materials you have lying around the house.

Christy

PHOTOGRAPHED THROUGH:

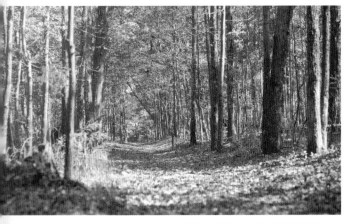

KID'S SUNGLASSES WITH YELLOW PLASTIC LENSES. I POPPED ONE LENS OUT AND HELD IT IN FRONT OF MY CAMERA.

KID'S SUNGLASSES WITH BLUE PLASTIC LENSES. I POPPED ONE LENS OUT AND HELD IT IN FRONT OF MY CAMERA.

KID'S SUNGLASSES WITH PINK PLASTIC LENSES. I POPPED ONE LENS OUT AND HELD IT IN FRONT OF MY CAMERA.

A STRETCHED-OUT BLACK SOCK SLIPPED OVER MY LENS.

A SCRAP PIECE OF TULLE SECURED TO MY LENS WITH A RUBBER BAND.

A PIECE OF PLASTIC WRAP SECURED TO MY LENS WITH A RUBBER BAND, AND A DAB OF PETROLEUM JELLY ON THE LEFT-HAND SIDE.

A PIECE OF WHITE TISSUE PAPER SECURED TO MY LENS WITH A RUBBER BAND. I CAREFULLY MADE SEVERAL SMALL TEARS IN THE TISSUE ONCE IT WAS IN FRONT OF MY LENS.

A PIECE OF PINK TISSUE PAPER SECURED TO MY LENS WITH A RUBBER BAND. I CAREFULLY MADE SEVERAL SMALL TEARS IN THE TISSUE ONCE IT WAS IN FRONT OF MY LENS.

AN EXTRA THICK SEMI-CLEAR LAWN BAG SECURED TO MY LENS WITH A RUBBER BAND.

A PIECE OF TEXTURED PLASTIC THAT WAS PACKAGING MATERIAL FOR THE KID'S SUNGLASSES, HANDHELD IN FRONT OF THE LENS.

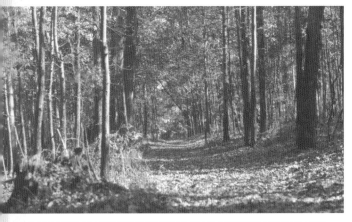

A SCRAP PIECE OF CHEESECLOTH SECURED TO MY LENS WITH A RUBBER BAND.

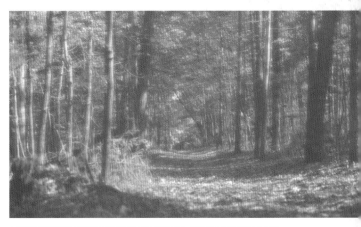

A SHEER WHITE SCARF SECURED TO MY LENS WITH A RUBBER BAND.

A PIECE OF PLASTIC WRAP FOLDED OVER FOR DOUBLE THICKNESS WITH WRINKLES, SECURED TO MY LENS WITH A RUBBER BAND.

additional materials to shoot through

∞ Vellum paper (add tears if it is too opaque)

∞ Transparencies

∞ Old negatives

∞ Glass slides

∞ Frosted glass

∞ Plastic beverage lids (clearish)

∞ Screening

∞ Mesh

∞ Sheer hosiery

∞ Remnants of plastic packaging

∞ Plastic wrap with dabs of oil in front

∞ Bubble solution

susan's tips for taking photos through different materials

∞ To add a foggy, blurred look to photos, carefully apply a thin layer of petroleum jelly or clear nail polish onto an inexpensive UV filter (you can find these for under $10). Experiment with applying the medium to different parts of the lens for a variety of effects. Try the bottom of the filter, the top or any place on the lens where you would like a blurred fog to appear.

∞ Colored holiday cellophane does the trick for a homemade colored filter. Just cut a piece slightly larger than the lens and secure it around the edges with a rubber band.

∞ As Christy illustrated, you can bend a wire coat hanger into a circle and stretch nylon over it for an instant softening filter (you can also try panty hose—in white, cream, pastel or nude).

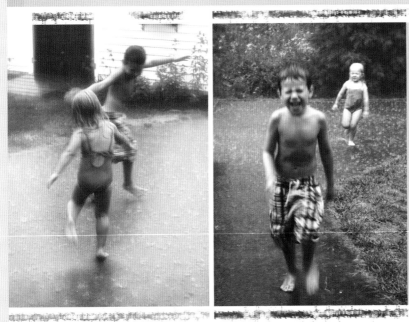

➤ **DISCLAIMER!**

Disclaimer: this is not a certified waterproof device.

I had to get that disclaimer out of the way before sharing with you a waterproofing trick I use with my iPhone. I drop it into a clear plastic bag and take it out in the rain with me to shoot. I've even used this method on amusement park water rides with the family. Have fun and play at your own risk!

RAINY DAY 1 BY SUSAN TUTTLE **RAINY DAY 2** BY SUSAN TUTTLE

ALTERED REALITY AND DREAMSCAPES: EXPECT THE UNEXPECTED FROM YOUR IMAGERY

5

Lauren Bacall once said that "Imagination is the highest kite one can fly." We invite you to tether yourself to this kite as the breeze begins to pick up and leap to explore the projects and prompts within this chapter. Alter your imagery with beeswax, discover a new and hip way to make a frame with crackle paste and add interest and intrigue to your favorite imagery with digital brushes. The sky's the limit!

Susan

artography and iPhoneography by christy

Somewhere along this journey, I began coloring and painting the thousands upon thousands of unsaturated and flat photos I'd taken. That creative process evolved into a digital blend of my photos and paintings, which I proudly call *artography*. And then a couple of years ago technology made it possible to do similar things on my cell phone—my cell phone of all things! How utterly amazing is that?

While these tips are intended for iPhone users, some of the techniques and general advice can be used on other devices, including digital cameras and computers. Since apps and technology advance at such a rapid rate, I will not go into specific tutorials but rather aim to empower you to create your own mobile masterpieces using these tips as a starting point.

SHOOTING WITH AN IPHONE: THE BASICS

∞ **Tap to Focus.** It's easy to forget that you can control where the iPhone will focus with the simple tap of a finger on your focal point. Why hello there, sharper image.

∞ **Expose Yourself** Tapping on different areas of your scene will automatically adjust the exposure. Use this to your advantage by tapping around and choosing the lighter or darker version you prefer.

∞ **Avoid Zoom** Tempting as that little zoom slider bar is, using it really degrades photo quality. Instead, take your photo at the normal range and then zoom into the photo afterwards by stretching it with your fingers. You can capture this "close-up" by taking a screen shot or croppig the image down via one of the many apps that do basic editing.

∞ **Accessorize** In the *Resources* section of this book I've listed some amazing lenses you can use with your iPhone, and by the time this book hits the shelves I'm willing to bet that list will have grown. These lenses expand the possibilities of your iPhone camera without affecting image quality. Think wide angles, macros and even telescoping lenses. Va va voom!

ALTERING TONE

Once you have captured your image, it is time to start thinking about the tone. Would it look better with a purple tint, in black and white, or perhaps that pink overlay would lend itself to a whimsical mood? Maybe you're feeling the vintage vibe today, instead, or maybe something with a dark contrast. Whatever your preference, apps make it oh so simple to preview and save as many toning variations as you can dream up. In the back of this book, you'll find a list of apps Susan and I particularly like to use for photo manipulation. Many of these apps have multiple useful features, including filters that will adjust the hue of your photo. At the moment, Qbro is my favorite starting point for fast tonal changes. Qbro and other apps have a key feature I look for—a way to adjust the strength of the filter. Rarely do I use these at full blast, and I've found that reducing the opacity helps prevent images from becoming overprocessed. It's the buildup of subtle layering that, in the end, will produce a rich piece of artography.

ADDING TEXTURE

Mmmmm. Texture. Rich, luxurious texture! I never tire of it; it is what gives my photos a painterly quality and wakes the dreamscape within. Texture can be as subtle or as bold as one desires, and there seem to be as many apps that produce it as there are textures. Apps ideal for adding texture offer an ability to rotate the chosen texture, a way to adjust the strength of it and the possibility of adding more than one. This can be done with a quick filter or by manually adjusting layers—it just depends on the app. Iris, PhotoForge2 and PicFx are the three I find myself spending the most time with now.

A FEW SAMPLES OF CHRISTY'S ARTOGRAPHY. SEE MORE AT INSTAGRAM—SEARCH USER NAME CHRYSTI.

susan's notes on iPhoneography

∞ *Although I am the model in nearly all of these photographs, I don't think of them as being self-portraits. To me, a self-portrait has a dimension of self-exploration, and I don't feel I am consciously exploring myself in these photos. Instead, I am using my body as the model, for convenience's sake, and because it is incredibly fun to play dress-up and act out a photo story.*

∞ *I invite you to try this. Let go and above all, enjoy yourself.*

∞ *You can read the story of how these photos came to be by visiting CreateMixedMedia.com/ photo-craft.*

SUSAN'S DAYDREAM IPHONEOGRAPHY SERIES CAN BE SEEN AT INSTAGRAM—SEARCH USER NAME ILKASATTICDOTCOM.

QUOTABLE

where words, photography and mixed-media art unite

On an average day, I see dreamscapes as wildly spectacular places that exist solely in my mind's eye. Typically they are ethereal, misty and always, always leave me a bit breathless. I yearn to walk right into them and explore the worlds I have created. However, dreamscapes can be so much more than that. In this project, we are going to explore the power of combining our emotions with words, photography and mixed-media techniques. These whimsical worlds feel a bit more tangible to me, something I can aspire to be, worlds to advise and inspire, as well as provide the emotional tug in which I take pure delight.

Creating harmony in an otherwise chaotic piece can be achieved through charming childlike illustrations and the color choices you make. While you can use any brand of acrylic paint, I work with Claudine Hellmuth's Studio Paints. Not only is the consistency a buttery smooth and creamy perfection, but the paints are coordinated! This means you have a practically instant color palette, which is oh so awesome for people who find it daunting. Base your color scheme on the colors in your photo and you can't go wrong.

Christy

WHAT YOU'LL NEED

Cradled wood board

Claudine Hellmuth Studio Paints

Claudine Hellmuth Squeezable Bottles

Acrylic glazing medium

Photo printed on art paper

Pencil

Workable fixative

Glue stick or YES! glue

Burnishing tool

Paintbrushes

Sandpaper

Incredible Nib, calligraphy pen or fine brush

Gel medium

Collage elements

Rubber stamp

Acrylic ink

Water bottle

1 Trace.
Place your photo on the substrate where you want it to go. Trace around it with pencil, and begin to plan your design. Work with the color, the mood and the composition present in the photo. For a cohesive piece, plan to pull elements from the image itself. I chose to add circles because some were present within the photo.

2 Get ready.
Mix 1 part white paint with 2 parts glazing medium and brush a thick coat over the surface. Once the paint has dried, sand over the whitewash and wipe away the dust. Next, pencil in your design elements. I created circles by tracing my paint jar; the rim is larger than the base, so it gave me two sizes to work with.

3 Collage.
Adhere the collage elements with gel medium brushing first on the surface and then press the paper into it while it's still wet. Brush another coat of medium over the top of the collaged paper, and repeat with each piece until all your elements have been adhered. Whitewash the surface again.

4 Paint, pencil and repeat.
Choose your colors and brush a thin coat of paint into your design elements. Once that has dried, retrace some of the illustration edges with pencil. Add additional collage elements, if desired, as you did in step 3. Allow it to dry completely, then sand the piece once again. Use a pencil to add more illustrations. Then whitewash over the entire piece and add more doodles.

5 Paint and blend.
Mix acrylic glazing medium with each of the paint colors, keeping them separate from one another. Repaint your design elements with this mixture and use any excess mixture to begin painting around the illustrations. Try to balance out your color by adding to opposing points—for example, if you place some paint on the lower left side, add some to the upper right next. Quickly repeat with each of your chosen colors while they are wet so you don't create harsh edges. Blending the colors while the paint and glaze is still wet gives a beautiful gradation of color that helps tie the chaos together seamlessly. Once dry, lightly sand the piece again.

6 Add the photo.
Glue your photo to the cradled wood board in the spot you marked earlier. Then thin out a bit of paint with glazing medium and brush it over your rubber stamp. Spritz the stamp lightly with a water bottle and randomly stamp over the canvas until the paint is used up. Begin to integrate your photo by allowing the stamp to overlap on top of it.

7 Keep going.
Doodle some more with your pencil, this time drawing on the photo itself.

8 Repeat step 5.
Add touches of paint onto the photo itself to help it become one with the canvas.

9 Add a quote.
With your pencil, write an inspiring quote, words of wisdom or a poem directly on the dried panel. Let the words overlap onto the photo, continuing its integration into the piece.

10 Ink over quote.
Dip your Incredible Nib first into water then into the acrylic ink. Carefully write directly over your penciled words. Doodle over other illustrations in your image using the ink to unify. Allow it to dry, and then seal with a workable fixative.

11 **Unify.**
Use a very thin whitewash over the entire piece to unify all the elements. Add white highlights to the letters and illustrations as well.

12 **Finish.**
Squeeze paint directly from Claudine Hellmuth Studio Paint bottles, adding details to various elements. When applied in this manner, the paint dries with a bit of dimension.

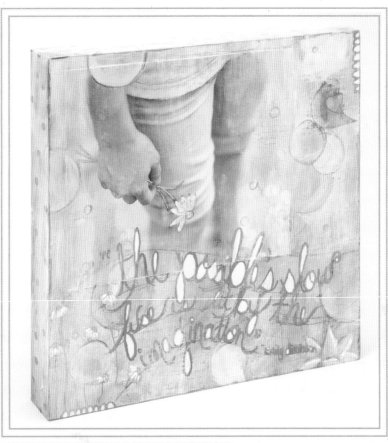

THE POSSIBLE'S SLOW FUSE IS LIT BY THE IMAGINATION
(EMILY DICKINSON) BY CHRISTY HYDECK

WAXING POETIC

creating ethereal images that are more original than their project name

Encapsulating photographs in wax offers a dreamlike quality that other mediums just can't achieve. If kept in proper conditions (i.e., away from heat), wax offers an archival quality that can last a lifetime. Wax complements black-and-white photographs particularly well in that it enhances their mystique. Color photographs also look exquisite, but remember that wax will mute the tones of the colors in your photos.

Different papers yield different results. The more porous the paper, the higher the chances of the wax bleeding through and creating transparent parts (which can be lovely). So experiment, experiment, experiment. In these projects I used glossy photos printed with my ink-jet printer.

Here you will explore a few of my favorite techniques using this amazing medium. Designed to be relatively quick and simple, I think you'll enjoy all the possibilities beeswax has to offer.

Christy

WHAT YOU'LL NEED

PART 1: PREP WORK

ADHERING THE IMAGE

- Sanded wood, the size of your printed image
- Sandpaper (if using a glossy image)
- Photographic print
- Adhesive
- Brayer
- Wax paper
- Optional: craft knife, self-healing mat

FINISHING THE EDGES

- Acrylic paint or gesso
- Baby wipes

HEATING THE BEESWAX

- Beeswax (I use bleached)
- Crock-Pot

PART 2: ENCAPSULATING PHOTOS WITH BEESWAX

VARIATION 1: SMOOTH AND DREAMY

- Melted beeswax
- Woodblocks of equal length
- Image mounted on wood
- Ladle
- Paint scraper

VARIATION 2: TEXTURE WITH CHEESECLOTH AND WAX

- Melted beeswax
- Cheesecloth
- Paintbrush

VARIATION 3: TEXTURE WITH WAX ONLY

- Ladle
- Pan larger than the photo (I used a roasting pan)
- Woodblocks of equal length
- Rubber stamp
- Optional: heat gun/quilting iron
- Scraper

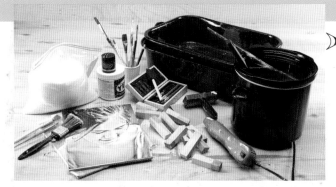

PART 1: PREP WORK

1 Sand a glossy photo.
If using a glossy photo, sand the back of the paper to give it some tooth for the adhesive to cling to. Wipe off any dust left behind. Brush adhesive onto the wood, covering the wood completely.

2 Burnish.
Place a piece of wax paper over the photographic print to protect it. Burnish the print to the wood by firmly rolling a brayer over it.

∞ TIP: Is your print larger than the wood? An easy fix is to flip the board upside down onto a self-healing mat, with the wax paper still protecting your print, and run a craft knife along the edges to remove the excess. Use sandpaper to remove the rough edges of the trimmed paper and watch it become flush with the perimeter of the wood.

3 Paint the wood sides.
Use a foam brush to paint the sides of your wood with a color that coordinates to your print. Brown, white and black tend to be my go-to colors.

4 Clean up.
The paint may pool up in spots. If it does, you can feather the paint onto the print with a baby wipe, giving it a distressed look. Or wipe it away before it dries to remove it.

5 Heat beeswax.
Place beeswax into a Crock-Pot and set it to low heat. Practice that whole "patience is a virtue" thing while it melts.

PART 2: ENCAPSULATING PHOTOS WITH BEESWAX, VARIATION 1: SMOOTH AND DREAMY

1 Prep wood.
Dip the woodblocks into the hot wax and place them on the bottom of the pan. The wax acts as a temporary adhesive, saving you countless minutes of cursing when the blocks fall over as you try to balance your image. Space out the blocks so the weight of the wood will be evenly distributed. Once your risers are in place, balance your mounted image on top of them. Eyeball it to see if the top is flat, or use a level to ensure that it is.

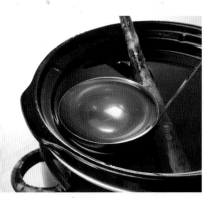
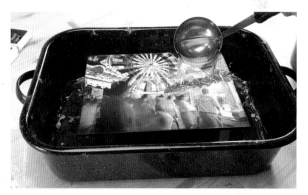
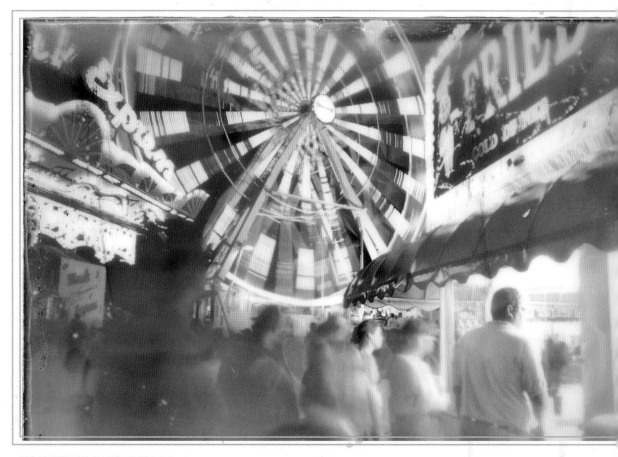

2 Work fast.
Dip your ladle into the melted wax and quickly but gently pour the wax over your photo. Work from the center out. Larger photos take several scoops (about two ladles for a letter-sized 8" × 10" [20cm × 25cm] picture). You need to do these quickly to prevent swirl lines from occurring; the wax needs to stay wet in order to blend smoothly.

3 Wait and scrape.
Let the wax harden a bit, about five to ten minutes. Place the scraper flat against the wood sides to remove excess wax. Then hold the scraper at an angle and gently run it along the top edge to give it a beveled finish.

THE COUNTY FAIR BY CHRISTY HYDECK
A SECOND COAT OF WAX WAS POURED ABOUT 45 MINUTES AFTER THE INITIAL COAT. THIS PRODUCED A TRANSLUCENT, MARBLE-LIKE EFFECT AND AN EVEN CLOUDIER, DREAMER FINISHED PIECE.

VARIATION 2: TEXTURE WITH CHEESECLOTH AND WAX

1 Add wax.
Brush wax in straight lines over the entire photo. The scruffier the brush, the rougher the texture will be.

2 Add cheesecloth.
Press cheesecloth into the warm wax. I like to pull focus to my main subject by placing the cheesecloth over the other elements in the photo. Brush over random spots with additional beeswax to vary the depth and texture. Bevel the edges as you did earlier.

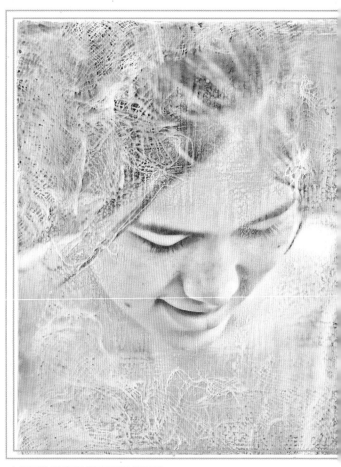

⌄ OPTIONAL
PULL THE CHEESECLOTH OFF THE PIECE WHILE THE WAX IS STILL WARM. THE WAX THAT SEEPED THROUGH LEAVES AN AMAZING, SPECKLED TEXTURE THAT CAN BE HIGHLIGHTED BY RUBBING A CONTRASTING PANPASTEL SHADE OVER THE TOP OF IT ONCE IT HAS HARDENED.

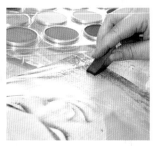

A JOYOUS MOMENT BY CHRISTY HYDECK
USING CHEESECLOTH IN CONJUNCTION WITH WAX ALLOWS THE FOCAL POINT TO REMAIN CLEAR WHILE PROVIDING A UNIQUE TEXTURE TO THE PIECE.

➤ VARIATION 3: TEXTURE WITH WAX ONLY

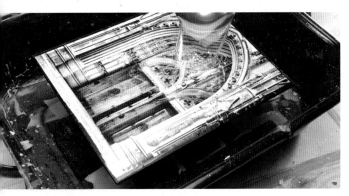

1 Ladle.
Follow steps 1–3 of Variation 1: Smooth and Dreamy, but only allow the wax to harden for about a minute or so.

2 Stamp.
Press a rubber stamp into the semihard wax and quickly remove it.

3 Add more beeswax.
Brush on additional beeswax in X patterns randomly over the board to provide a contrasting texture. For yet another variation, use a small quilting iron instead.

4 Finish.
Scrape away thin layers of wax from your focal point or other elements in your photograph that you wish to highlight. If the wax has become too hard, you can soften it a bit with a heat gun. Bevel the edges as you did earlier.

A NOBLE LIFE BY CHRISTY HYDECK

TISSUE PLEASE
dreamy possibilities with tissue paper and wax

Printing on tissue paper opens up so many possibilities. The wax often renders parts of the image transparent while obscuring other parts, which results in a dreamy effect. The best part is that it is surprisingly easy. If you can wrap a gift, you can do this.

Christy

WHAT YOU'LL NEED

Ink jet printer (I haven't tried this on a laser printer)

Tissue paper

Subject Photo

Scotch tape

Printer/copy paper

Cradled wood panel or canvas

Melted wax

Scissors

1 Prep tissue.
Cut a piece of tissue paper roughly an inch bigger on all sides than your printer paper.

2 Secure.
Center the tissue over your printer paper. Fold the tissue snugly around the paper and crease it so the overhang is on the back of the printer paper. Fold the corners flat, and tape the tissue all the way around. Be sure there are no loose pieces sticking up; render it as flat as can be. If you don't do this, you risk jamming your printer and we all know what a hassle that is!

3 Print.
Follow your printer's instructions for feeding through the secured tissue paper. Print your image.

4 Cut.
Cut your photo out of the tissue paper. It is much easier to do this with the printer paper attached to the tissue paper, keeping it firm.

5 Wax.
Brush wax onto your wood or canvas surface and place the tissue image into the wax while it is still warm. If it hardens too quickly, just use a heat gun to remelt it. Choose any of the methods discussed in the *Waxing Poetic* project to seal the top of the image with wax.

TECHNICOLOR DREAMWORLD

transform your photograph with unexpected colors and a custom brush

Photoshop has a plethora of tools that will allow you to create a technicolor, fantasylike image from just a single photograph and a texture brush. This project focuses on the application of a rainbow-colored Gradient Fill—an often-neglected fill that I am happy to promote because it is so fun to use. I will then show you how to apply a lace custom brush to enhance the dreamy atmosphere. Once you learn how to load a custom brush, a whole new world of Photoshop will open up to you. Check out the lengthy list of brush resources in the Resources section—endless playtime!

WHAT YOU'LL NEED

DIGITAL MATERIALS

Subject photo (a human face works—adapt the instructions to fit your photo choice)

Custom brush: lace

SOURCES FOR PROJECT ARTWORK

lace6 brush from www.obsidiandawn.com (part of the Lace Brush Set)

TECHNICAL SKILLS

Duplicating a file

Adding a Solid Color Fill Layer

Adjusting the Blending Mode of a layer

Adjusting the Opacity of a layer

Feathering

Adding a Gradient Fill Layer

Creating a New Layer

Loading a custom brush

Selecting colors

USING TOOLS

Lasso Tool

Eraser Tool

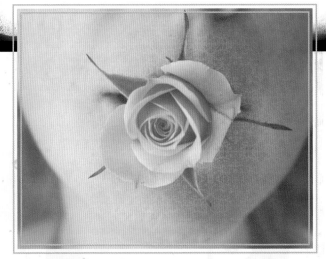

EXTRA-ORDINARY BY SUSAN TUTTLE

THINK OUTSIDE THE BOX WHEN APPLYING COLOR.

1 Duplicate the file.
Duplicate your subject photo. This will be your working file.

2 Add a soft sepia tint.
Apply a beige Solid Color Fill Layer (#c6ac84) and set the Blending Mode to Color and maintain 100% Opacity.

3 Select the rose and Feather your selection.

Use the Magnetic Lasso Tool to select the rose. I feathered the selection with a Radius of 30 pixels.

4 Apply unexpected color to the rose.

Apply the Transparent Rainbow Gradient Fill to the rose layer. I kept the Blending Mode setting at Normal and reduced the Opacity of this layer to 12%.

5 Apply a Gradient Fill.

Soften the look of your photo by adding a Gradient Fill. First choose a color for fill. In this project I used white (#ffffff). I applied the Fill Layer with the following settings: Blending Mode: Normal; Opacity 30%; Gradient: default mode (which is "foreground to transparent"); Style: Linear; Angle: -32.74.

6 Add custom brush texture.

Create a New Layer and add a custom lace brush. Size the brush to fit the image and stamp with it by clicking once. I used the following settings for this layer: Blending Mode: Normal; Opacity: 33%.

7 Erase lace pixels from the rose and mouth.

To reveal details of the rose and mouth, use the Eraser Tool (soft brush setting with a reduced Opacity—anywhere from 40-60% Opacity) to erase the lace in these areas. Note: Erasing over an area multiple times increases the amount of pixels erased.

Save file.

tips · prompts · variations

Experiment with adding more than one Gradient Fill to your image for an enhanced dreamy atmosphere. I like to do this with white-colored Gradient Fills. Try out different angle and Opacity settings.

Other resources for custom brushes (be sure to check terms of use) include: www.inobscuro. com; www.photoshopbrushes.com/brushes.htm; www.damnedinblack.net/brushes.htm; www.annikavonholdt.com/brushes; www.missm.paperlilies.com/01_brushes.html; and www.deviantart.com.

GUEST SPOTLIGHT: ALTERED REALITY WITH COLOR

⊳ Linda Plaisted

This piece is from my "Luna Park" series of carnival and amusement park images. The first thing I did was layer, using Photoshop Elements, my original photograph of a roller coaster in motion with several detailed photographs of textures. This lends the finished piece a more painterly, dreamlike quality. I then chose to make some of the layers recede and some of the layers to move to the surface by alternating my choices in lighting, color, saturation, hue and luminosity. Finally, I altered the blunt reality of the original image by selectively blurring some of the details to enhance the illustrative, romantic perspective I was seeking to convey.

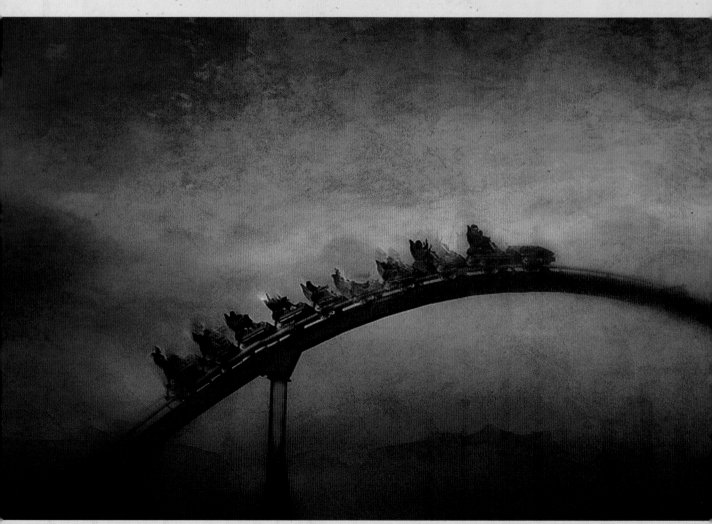

SHOOT THE MOON BY LINDA PLAISTED

GUEST SPOTLIGHT: CUSTOM BRUSHES

➤ **Pilar Isabel Pollock**

Thunder was created by applying several layers of brushwork. I first highlighted the horse by coloring him with a rust tone and then adding a grunge texture to enhance the color. Next I added layers of brushwork to distress the photograph, and I also applied several Blending Modes to these various layers—including Overlay, Soft Light, Hard Light and Linear Burn.

MATERIALS

PROGRAM USED

Adobe Photoshop Elements 7.0

Texture: Grunge Texture by Env1ro (http://env1ro.deviantart.com)

BRUSHES

Adobe default brushes

Obsidian Dawn (obsidiandawn.com): Distressed,Grunge Scratches, Grunge and Dirty, Scratched Out, Splats and Splatters, Water Stains, Handwriting

Jose Chagas (myphotoshopbrushes. com): Old Photo

THUNDER BY PILAR ISABEL POLLOCK

➤ FOCAL POINT

photograph your favorites in different ways

Imagine one of your favorite things. What do you see? What are your senses experiencing as you meditate on it? How does it make you feel? Now try to capture the essence of this favorite thing by photographing it in a variety of ways.

∞ Experiment with the focal length of your camera lens. Get close up or far away, if your lens allows.
∞ Shoot from above, at ground level and at different angles.
∞ If your favorite thing is an object, photograph it against interesting backgrounds, or perhaps photograph it being held in your hand(s).
∞ If you are photographing a person, get close, at their level, and shoot straight on, then proceed to move around their body and photograph many viewpoints. For portrait photography, consider using a lens with a longer focal length so you can take up-close pictures without having to stick the camera directly in the person's face (I use my 15–85mm wide-angle zoom lens set to a long focal length).

∞ For landscape photography, think about the different points of view that you can convey as you photograph your favorite spot. Perhaps get down on the ground with your camera, making solid earth the main focal point, or aim higher with your lens, taking into account the sky and horizon. As you compose your photo through your lens, think about what you want the lens to focus on and what content you wish to see in your photo's foreground and background. Try shooting in a variety of weather situations, observing how the weather affects the feel and mood of your photos.
∞ Photograph your favorite thing at different times of the day, capturing the way it looks bathed in light casts of varying intensities and shaped by the resulting shadows.

Susan

COFFEE—LET ME COUNT THE WAYS I LOVE IT! BY SUSAN TUTTLE

ONE OF MY FAVORITE THINGS IS A HOT, BOLD CUP OF COFFEE IN THE MORNING. MY HUSBAND AND I HAVE A LARGE COLLECTION OF VINTAGE MUGS THAT WE ENJOY SIPPING FROM AND DISPLAYING ON A SPECIAL HANDMADE RACK IN OUR KITCHEN. I CHOSE TO COMBINE BOTH OF THESE ELEMENTS AS I PHOTOGRAPHED MY FAVORITE THING IN A VARIETY OF WAYS WITH MY CELL CAM. I AM SURE YOU NOTICED THE PIECE OF BIRTHDAY CAKE—THAT'S ANOTHER OF MY FAVORITE THINGS. HERE ARE A FEW OF THE IPHONEOGRAPHY APPS I USED TO MANIPULATE THESE PHOTOS (PLEASE NOTE THAT THESE APPS MAY BE OBSOLETE BY THE TIME THIS BOOK IS PUBLISHED): IDARKROOM, CAMERA+, FOCALLAB, PIC GRUNGER, SKIPBLEACH, PHOTOTREATS, IRIS. FOR MORE APPS, CHECK OUT THE RESOURCES SECTION NEAR THE END OF THIS BOOK.

susan's field trips • photo shoot
idea list

∞ Photograph a favorite person in several environments: perhaps indoors gazing out a window, engaging in a favorite activity or in an natural outdoor setting. You might even want to have a fun dress-up session (I frequent local thrift shops for funky vintage outfits, costumes, wigs, accessories and fancy dresses just for this purpose). It's fun and freeing and will give you some good doses of belly laughter. Apps used for the montage include Camera+, MagicHour, iDarkroom, SkipBleach, Filter Mania, TiltShiftGen, TrueHDR, qbro, and Photo Glitter. For more apps, check out the **Resources** section near the end of this book.

∞ Aim to capture movement to convey drama.

To achieve this, place your camera on a tripod and set it to a slow shutter speed. Maybe you will photograph your daughter spinning in her favorite party dress, the movement of a waterfall you love or your dog running across your yard or a field. If you are taking a picture with a cell phone camera, an app called Slow Shutter will replicate this camera action.

DRESS-UP PHOTO SHOOT

christy's
field trip • mini-challenge
ideas

∞ Time Lapse: Pass the same beautiful tree or other landmark daily? Consider documenting its changes daily, weekly or monthly. Visually seeing the progression and changes isn't only inspiring, but it helps shape your perspective too.

∞ Confucius said, "Everything has its beauty, but not everyone sees it." Teach yourself to see. Step outside of your comfort zone and photograph things you don't particularly like. Make yourself uncomfortable and choose an object you are not at all drawn to. Though it may seem difficult at first, challenge yourself to find beauty within it. Maybe it's the way light plays off it or the curve of the lines. Perhaps the color up close is vivid and spectacular. Look for those little things that make up the whole and capture them with your lens.

∞ Photograph one of your collections. Document each item individually. Once complete, use a digital manipulation technique or turn them into Thermofax screens and use the images of the things you love within your art.

USING HER IPHONE, CHRISTY PHOTOGRAPHED ONE OF HER VINTAGE CAMERAS IN A VARIETY OF WAYS AND TURNED IT INTO A MONTAGE WITH THE PHOTOSHAKE APP.

YOUR WORDS, YOUR IMAGES + UNIQUE PHOTO JOURNALING

6

Why do so many people wish to unearth and record their innermost thoughts in journals, whether they be written, visual or a combination of both? Perhaps it is because we are human, and part of the human condition means having a profound need to connect with soul—our own and others. Artistic self-expression is a powerful way to make these connections, and in this chapter we hope to give you tools that will help you access your innermost, creative self as you explore art journaling on a variety of levels.

Susan

PHOTOS/ART BY CHRISTY HYDECK

I was in grade school when I had my first brush with graffiti. A friend taught me how to dampen a photo and etch into it with a sharp object, removing the color and allowing my words, squiggles and doodles to appear. I have been hooked ever since. What began as childish marks has evolved into a grown-up love affair with words.

To begin, grab a glossy photo that visually stimulates you. Spritz it with water or dampen it gently with a baby wipe, and grab a pointy instrument like an awl to write with. Etch the first word you think of—*any word*. Then just let it flow. Whatever you are thinking of, etch it. And don't worry about silly things like sentences, grammar, syllables or spelling. After all, they are just words. Pretty words. Silly words. Personal words. Angry words. Words that express the full gamut of emotion. They're inside of us and they are utterly authentic, so feel free to embrace them without any added stress.

What I love about this mini project is that no matter what words you choose, they create movement and motion with your photograph. Your eye follows the lines of the verbiage, regardless of what it says. Ah yes—poetry in motion. Does it get much better than that?

(By the way, there's an app for that; try TypeDrawing or WordFoto.)

Christy

108

A poem that comes from you is nothing short of a miracle: its origins the depths of your heart; words woven together into dreams, thoughts, ideas, imagination, inspiration. Poems can act as powerful prompts and cues that inform our photography, and conversely, photos can inspire the written word.

Finding a starting point for a poem, plumbing your heart for just the right words, can sometimes be challenging. I often use a variety of techniques to draw out the poems that have been there all along. We are all poetic dowsers, so to speak. Here is a fun exercise that I like to use.

Free verse is a style of poetry that does not have to rhyme or follow a regular meter. Instead, it's organized according to natural cadences of common speech. Use the exercise below as a writing prompt to help you compose your own free verse poem.

Generate three lists: action words, names of things and descriptive words. I recommend having about 25 words per list. Feel free to make up words (I made up the word **birdless** in the exercise). Draw from these lists of words in any way that you wish, constructing a poem that is at least five lines. You can add words that are not on the list as well. Don't feel bound in. Use this exercise as a sort of springboard or scaffold for your writing.

MY SAMPLE LISTS:

Actions: recite, spin, reach, retreat, pull, wake, feel, question, disappear, guzzle, revel, find, protect, drink, free, shift, weave, spur, draw, cast, birth, engrave, furnish, tear, collect.

Things: breath, stone, cave, mural, lens, miracle, footsteps, liquid, telescope, dream, poem, watercolor, sky, compass, sleep, poet, room, sight, quiet, wind, chair, pathway, snapshot, mural, food.

Descriptives: red, salvaged, muddy, melting, handwritten, freckled, perfumed, overgrown, breezy, golden, jagged, birdless, transient, glittering, silent, detached, original, pink, simple, molten, giddy, emerging.

MY POEM:

DAY'S WORK

she.
drawing breath,
reciting a dream in the quiet room.
snapshots glittering through a birdless sky lens,
spinning
floating
emerging
collecting
like golden pools of molten miracles.
she.
freckled, pink cheeks reveling up.
meticulous soulwork.
shifting light.
pulling questions from the clouds,
telescoping hand-written notes from
the quills of angels.
painting watercolor skyscapes with
brushes dipped in river water.
drip.
drip …
…happy, stained cheeks,
pursed, red lips sipping
liquid from a stone.
retreating to the gauzy cave of
overgrown rosebeds and the perfumed silence
of dreams.

THIS SELF-PORTRAIT PHOTOGRAPH OF MY BODY WRAPPED IN GAUZY TULLE INSPIRED THE POEM I WROTE WITH THIS FREE VERSE EXERCISE. IT IS ABOUT A DAY'S WORK WITH OR IN THE CREATIVE PROCESS.

THE PERFUMED SILENCE OF DREAMS
BY SUSAN TUTTLE

DIGITAL STORYBOARD

artfully documenting special life moments

Although I enjoy creating from scratch using a mix and match of materials and tools I keep in my digital "art bag," there are times that I could use a little help to get started. Having a given set of tools and a structure to work with are often just the things I need to draw out my creative ideas. In this project, I demonstrate how to use one of Michelle Shefveland's digital Storyboard templates, along with some of her additional Storyboard products. You can customize the template in all kinds of ways to make it uniquely yours as you build your visual story.

Susan

TELL YOUR STORIES WITH A CREATIVE
DISPLAY OF MEANINGFUL PHOTOS.

tips · prompts · variations

∞ Instead of using digital paper for your background, use one of your high-resolution photographs and lighten it with the Levels function. Go to Enhance> Adjust Lighting> Levels and increase the black point triangle output level. For this project, I could use the photograph of the water as the background, as it ties the piece together and makes a nice, simple base without too much detail or distraction.

∞ Add some of your own digital elements to the template.

WHAT YOU'LL NEED

DIGITAL MATERIALS

Subject photos (a variety that tell a story)

Font

SOURCES FOR PROJECT ARTWORK

The storyboard template, paper and frame are credited to Michelle Shefveland and can be purchased at www.cottagearts.net.

TECHNICAL SKILLS

Duplicating a file

Moving a file into another

Creating a Clipping Mask

Arranging a layer

Resizing

USING TOOLS

Marquee Tool

Type Tool

1 Duplicate the file.
Make a copy of the template to preserve the original template. This copy will be your working file.

2 Add first subject photo.
Open your first subject photo, and click and drag it onto the template. Move it to the first Polaroid and resize it so that it will fit the Polaroid (just eyeball the size and don't worry about being exact at this point). Note: If the photo is too small, make the template smaller. If you increase the size of the photo, you sacrifice quality.

3 Select the photo mask.
Select the photo mask (the colored square) of the first Polaroid by clicking on it in your working file. Clip the photo to the mask by going to **Layer> Create Clipping Mask**.

4 Fit photo into place.
Move your first photo into place behind the mask opening and resize as necessary. If part of your photo hangs outside the Polaroid, use the Marquee Tool to select that portion of the photo layer and press delete on your keyboard. Repeat steps 1-4 for all photographs.

5 Add background paper.
Open your background paper file, and click and drag it onto the template. Select the template background by clicking on it in your working file. Move the paper into place.

6 Add text.
Select the Type Tool. Click and drag over a text layer and enter your own text. You can experiment with different fonts, colors, sizes, alignment and styles. Keep in mind that these are text layers and function just as any other layer would—you can move them around the template. Save File.

FOTOFILE

embracing the art journal through happy accidents,
photography and upcycled materials

Three things are inevitable when I create:

∞ There will be a mess, often of epic proportions.

∞ Iced coffee will most certainly be consumed.

∞ A journal will remain by my side so that I have a creative surface upon
which to wipe those extra bits of paint and glue leftover scraps of paper.
Here I can also safely test stamps, experiment with color and so on.

That third one—the journal? It's a great way to reduce waste while
accumulating ephemera for your fotofiles. Save some of that junk mail and
the paper bags that result from your shopping sprees. Keep test papers and
receipts and leftovers. All of these materials can be used in making and
decorating journals.

I also have my favorite iPhone photos printed monthly through a service called
Postal Pix, and the 4" (10cm) squares are the perfect addition to these upcycled
journals. Once the photos have been added, I have this utterly fabulous and not
too blank canvas ready to collect my thoughts, dreams and bad jokes. I keep the
pages to a minimum to not only prevent the folder from bursting, but also so that
I have a chance of actually completing an entire journal, which is something I am
not prone to do with thicker books.

Christy

WHAT YOU'LL NEED

MAKING THE BASE

File folder

Decorative papers

Yes! Paste (doesn't buckle the
paper as a wet medium would)

Brush

Brayer, bone folder, old credit card
or other burnishing tool

Book cloth tape

Craft knife

Sandpaper

PREPARING THE PAGES

Assorted sizes and styles of
upcycled paper (painted papers,
ephemera, misprinted photos,
paper bag pieces, decorative
papers, etc.)

Bone folder

Paints, gesso (optional)

PUTTING IT ALL TOGETHER

Waxed thread

Awl

Needle

Self-healing mat (optional)

DECORATING THE JOURNAL

Photos

Adhesive, glue stick, mounting
squares, decorative tapes

Writing instruments

Collage scraps

Ruler

Ink pad

Rub-on transfers and/or other
embellishments

Sandpaper

MAKING THE BASE AND PREPARING THE PAGES

1 Prep.
Brush a thin coat of Yes! Paste onto one side of a file folder. Place a sheet of decorative paper over it and burnish it with the tool of your choice to ensure the bond. Repeat on each side. Once the glue has dried, use a craft knife to free the excess paper from the edges; place it over a self-healing mat and slowly run the edge of the knife along each side of the file folder.

2 Sand.
Gently rub a small piece of sandpaper along the edges, for clean lines and a slightly distressed look.

3 Tape.
Cut a piece of book cloth tape long enough to cover both the inner and outer part of the folder spine. Center it, and stick it to the surface—let the edges meet on the inside. Burnish it well to ensure adhesion.

4 Prepare the pages.
Crease each page where you want the middle to be; a bone folder is particularly helpful when dealing with thick papers. Pages are often more interesting when the sizes vary, so let go of perfection and embrace odd, random creases and sizes. Stack the papers in the order you want them, aligning each of them with the crease.

tip

It is often easier to paint the backs of papers at this stage, before stitching it together. If you have an aversion to blank pages, paint them now.

5 Begin assembly.
Line up the creases in the paper with the inside center of the file folder. Place the stack over a self-healing mat to avoid damaging the surface below. Use a sharp awl to punch a hole through all the pages as well as the folder spine. Repeat along the entire spine. More precise folks may prefer to measure this one out for even spacing.

6 Finish assembly.
Use a sharp needle to pull the waxed thread through the first hole. Knot the thread on the outside spine of the journal so it doesn't pull through. Continue sewing up the spine until finished. The last hole should allow for the thread to end on the outside of the journal. To finish it off, tie a knot.

tips

∞ *Adding a coat of gesso to paper bag pieces and other thin surfaces helps with stability.*

∞ *Add pockets on the inside cover to store even more photos, lists or ideas. Paper bags make great pockets in a pinch.*

∞ *You can also add a very thin whitewash over the entire piece to unify all the elements. Add white highlights to the letters and illustrations as well.*

∞ *Your not-too-blank canvas is just waiting to be the keeper of your lists, thoughts and paintings. Carry it with you so you can work on in stages. Before you know it, the pages will be filled and you can move on to the next fotofile.*

7 Decorate the journal.
Add a photo to each page. Be bold and allow some photos to hang off the edges of the papers. Glue old text pages or decorative paper to the backs of those photos. Remember to sand the back of the photo for better adhesion.

Go through the journal, adding embellishments, inking up edges, sketching lines, adding doodles; the sky is the limit here.

Write prompts at the tops of some pages to make journaling in the future a bit easier.

GUEST SPOTLIGHT:
INSPIRATION + TECHNIQUE

❯ Samantha Kira Harding

When I moved to Arizona from Chicago, I thought I'd be giving up my lovely trees and plants for a rust-colored desert. I was pleasantly surprised to find all sorts of beautiful flowers and fauna around my new apartment, and I decided to capture them with my camera. This journal is my tribute to my new home and all the beauty I've discovered. I wanted to showcase what I'd found as well as what I'd left; it's been a journey that has helped create in me a newly inspired self.

Using photos printed at a local store (some of which I altered in Photoshop) I journaled on loose sheets of printmaking paper, letting the photos and colors tell the story. I collaged, painted and stamped to create a sense of sanctuary on the page. The cover is canvas that I stitched together and punched holes in, and the pages are bound together with colored binder rings. The cover photo was printed on sticky-back canvas and is easily one of my favorite photographs. I never thought I'd take a good photo—now, I know I can!

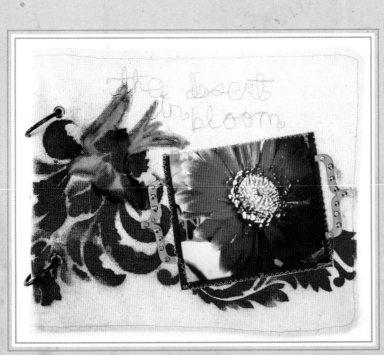

THE DESERT IN BLOOM BY SAMANTHA KIRA HARDING

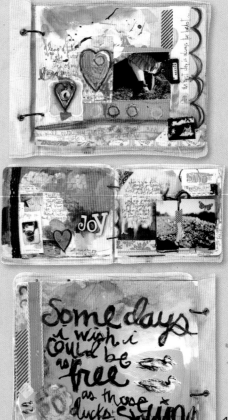

➤ FOCAL POINT

When taking photographs, you can draw inspiration from your very own written words, whether they be a poem, a scribble of a quick thought or a letter to a dear friend. Find something within your words that stirs you, and meditate on them as you ready your camera. Let the words be your guide and let them lead you to taking a photograph that will represent its sentiment.

For this Focal Point, Maddie Mulvaney uses a beautiful poem that she typed up on her vintage typewriter to serve as inspiration. She shares it with her daughter Tess, and together they go to the beach with camera gear in hand. Tess captures a visual to represent her mother's poem, replete with delicate grace and beauty.

Susan

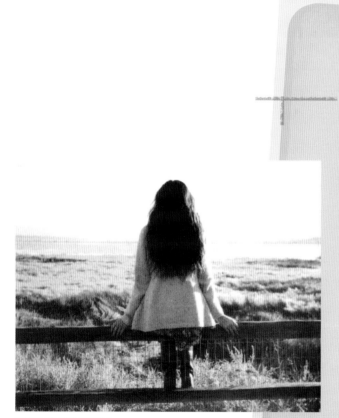

PHOTO BY TESS HERZOG

field trips + photo shoot idea list

You can find words of inspiration in any number of places. Here are a few locales you might want to check out:

∞ *Online random word generator; try creativitygames.net/random-word-generator*

∞ *Magazine article titles*

∞ *Dictionary or thesaurus*

∞ *Book of poems*

∞ *Song lyrics*

∞ *Find a movie channel and hit the mute button on your television remote. Click it back on at a random moment for a couple of seconds. Use the words that were spoken as your source of inspiration.*

∞ *Online poetry prompts; I am a fan of writingprompts.org.*

Come see the light with me!
this morning
 tiny violets yawning
frozen summer peaches

 yellow bees
traipse around the sky
happily yelling goodmorning
 to one another

and birds fly
breaking loose in green winds

it smells sleepy and warm
like coffee
and the holding of hands
while the wind skips stones
builds sandcastles

once upon a time I was a mystery
 now I am a river flecked with seeds
this much I know

I go with all of my being towards love
(noisily)
a ruby in my hair
a whirl of petals

when I listen carefully
I can hear myself singing

 still...

I will leave a piece of myself behind
a white butterfly

 barefoot

POEM BY MADELYN MULVANEY

UPCYCLING: CREATIVE USES FOR YOUR FORGOTTEN PHOTOS

7

Upcycling! Basically, it means taking something that you would ordinarily toss away and finding a way to turn it into something else, whether that something else be artistic, functional or both. In this chapter we will demonstrate a variety of ways to take your photographs—some of them lost and forgotten within shoe boxes or the digital photo archives on your hard drive—and reinvent them as unique, captivating works of art. Create a colorful "floating" frame with resin, display a photo in a faux glass block that you make with the leftover resin (we won't be wasting a thing here) and use portions of these "forgotten" photos to construct a "bubbly" abstract painting. Use your digital darkroom to create a digital frame from a scan of your artwork, and use the Liquify filter to transform your photo into a faux "wet on wet" abstract painting. Collect handfuls of those old photos, arrange them into your favorite shape, and photograph them. Or, arrange them in the form of a digital montage. Upcycling—it's the ultimate DIY!

Susan

PHOTOS/ART BY CHRISTY HYDECK

susan's notes on faux glass blocks

Consider using this technique to frame one of your digital journal pages or storyboards. It's a special way to frame a keepsake.

CHRISTY'S FAUX GLASS BLOCK

THE OCD SIDE OF ME JUST CAN'T GRASP LETTING ANYTHING GO TO WASTE. WHEN I MAKE RESIN FLOATS, I USE THE EXTRA RESIN THAT PUDDLES UP ALONG THE SIDES OF MY WORK TO CREATE THESE FASHIONABLE, YET FUNCTIONAL, FAUX GLASS BLOCKS. THEY MAKE A GREAT PAPERWEIGHT WITH A MINIMALIST FLAIR. WITHIN TWENTY MINUTES OF POURING THE RESIN, I SIMPLY USE A PLASTIC SPOON TO SCOOP UP THE LEFTOVER RESIN AND LINE THE BOTTOM OF THE MOLD WITH IT. I LET THAT SET TO A GEL-LIKE CONSISTENCY AND THEN GENTLY PLACE MY PHOTO ON TOP OF IT. ONCE THAT IS CURED, I POUR A THICK COAT ON TOP. HOWEVER, IF YOU'RE MORE PATIENT THAN I AM AND PREFER TO AVOID BUBBLES, YOU CAN ADD THE RESIN IN THIN LAYERS. ONCE IT HAS DRIED, WIGGLE IT OUT OF THE MOLD, MUCH AS YOU WOULD ICE FROM AN ICE CUBE TRAY.

RESIN FLOATS
much kinder to your waistline than the root beer kind

One of the many reasons I am drawn to photography is the fact that it magically captures this one seemingly insignificant, amazingly beautiful, gone-in-the-blink-of-an-eye moment in time. The magic of photography seems so precious to me—as if you are catching a single fleeting breath on a cold winter day and harboring it in an old glass jar. It instantly takes me back to the wondrous feeling I had as a child; floating my summers away in the swimming pool, eyes closed, sun warming my body as I drifted across the water on my back for what seemed like hours. I **absolutely** loved the easy, carefree feeling that came with the weightlessness. What if we could do that with the fluidity of paint? Suspend one simple fleeting moment for eternity?

Contributor Michele Beschen shared a project on her must-see television show, *B. Original*, which inspired the starting point for these vibrant resin floats. They capture the swirling, liquid motion of paint and allow viewers to enjoy that happy moment time and again. Combined with your imagery and a hefty dose of color, these are sure to bring a new level of dimension to any photograph.

Christy

WHAT YOU'LL NEED

Wood (sanded)

Pencil

Ruler

Photo print—I used a glossy photo; different papers will yield different results. (The more porous the surface, the more likely it is that the resin will permeate it.)

Baby wipes

Charcoal pencil

Blocks/support to raise the board

Resin

Acrylic glazing medium

Claudine Hellmuth Studio Travel Size Squeezable Paints (or other acrylic paint in squeezable bottles)

Brushes

Sponge brush

Photos

Glue stick

Pointy object such as an awl or a screwdriver

Ephemera

Heat gun/propane torch

Plastic tarp

Spatula

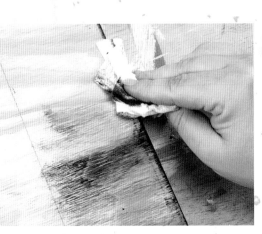

1 Prep surface and draw grid.
Cover your work surface with plastic tarp. Then use a pencil and ruler to design your grid. Make at least one of the rectangles roughly the size of your photo print. Paint the sides of your wood black (or any color you desire) with a foam brush.

2 Paint the grid.
Letting the colors in your photo guide you, choose a color palette that either directly matches or complements the picture. Paint the first color into one of the rectangles. Brush off the excess paint randomly in the other squares. Repeat the process with each of your chosen colors.

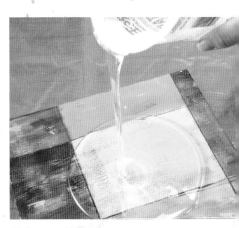

3 Glaze randomly.
For each color used, mix a few drops of glazing medium with a drop of paint. Brush on the tinted glazes randomly over the piece, blending the colors together for a cohesive, balanced look.

4 Redraw with charcoal.
Redraw each of the lines with charcoal, using a ruler as a guide to keep the lines clean and neat.

5 Pour resin.
Prop up your piece on blocks or some sort of riser. Mix your resin according to the manufacturer's instructions. Slowly pour the resin into the center of the board and allow it to spread. A wooden spoon or spatula can help you spread it to the places that may not be perfectly level. Hurry into the next step so you can work while the resin is fluid and wet.

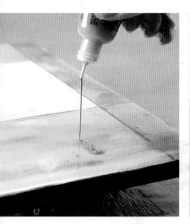
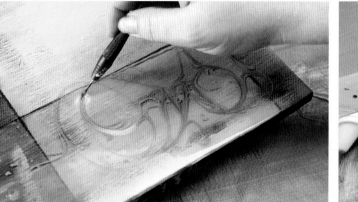

6 Add paint to wet resin.

Squeeze drops and thin lines of paint directly into the wet resin. Swirl the paint and fan out some designs by dipping a pointed object into the wet resin and spreading it with the tip. As the resin dries, it will slowly move and drizzle off of the sides. The paint will move with the resin, so expect your painted designs to change a bit. Repeat with additional colors of paint, if desired.

7 Wait patiently, remove bubbles, wait some more.

Wait 5–7 minutes, then check back. If bubbles have developed in the resin, follow the manufacturer's recommendations for removing them. Next, patience. The piece must dry completely. Chances are, it will take at least a day.

8 Add ephemera and finish.

After the piece has dried, adhere ephemera with a glue stick. Repeat steps 7 and 8. Use a glue stick to adhere the photo print. Keep adding resin, paint and ephemera (steps 7–9). Let the resin dry between layers so that each finished layer will float at different heights. My finished piece had eight layers in all. Once you're happy with the depth, add just one final coat of clear resin to seal the deal and accentuate the depth.

COLOR MY WORLD BY CHRISTY HYDECK

BEVELED FRAME

transform your mixed-media art into a hip photo display

Blank walls begging for color will thank you for this project. When Christy sent me a photo of her completed resin float project for this book, I became totally smitten with the luxurious layers, rich, bright, flavorful colors and whimsical splashes of texture. An idea popped into my head—I imagined scanning the floats, deconstructing and reconstructing them, and then transforming these parts into a unique digital frame with which to display a favorite photograph.

Susan

DREAMING OF MANAROLA BY SUSAN TUTTLE

1 Duplicate and transform to transparent.
Open a New Blank File and size it as desired (mine is 10" × 10" [25cm × 25cm]) with a resolution of 300 dpi. Set the Color Mode to RGB Color and set Background Contents to Transparent. This will be your working file. Open your scan of mixed-media art. Select and add a part of the original art file to the transparent file; use the Rectangular Marquee Tool to make the selection and move it to the working file. Resize and rotate selection as needed.

2 Repeat step 1, arrange and merge layers
Repeat step 1 until you have filled the entire transparent file with selections from your scan. Arrange layers as necessary. When finished, merge the layers. Create an opening in the center of your frame. Make the selection with the Rectangular Marquee Tool and hit "Delete" on your keyboard, revealing a portion of the transparent file layer below.

3 Bevel edges and save.
Perform Select> Deselect. To bevel the edges of your frame, go to the Effects Palette and choose "Bevels" from the Layer Styles pull-down menu. I chose "Simple Emboss" and then hit "apply." Open a file of your favorite photograph and move it into the frame. Arrange layers and resize as necessary. Save the file.

➤ You can then print out your frame and place a photo behind it, or try using it in a scrapbook.

123

TURN YOUR PHOTO INTO ABSTRACT ART

replicating a wet-on-wet painting technique

Who wouldn't enjoy dipping multiple brushes into paint, splattering a canvas with reckless abandon and pushing paint around the surface in every direction? When your creative space is not conducive to this type of artmaking, why not try splashing some digital "paint" around with the Liquify Filter Tool? You can create swirls of color that replicate a wet-on-wet painting technique. And the cleanup is a snap—I promise.

Susan

WHAT YOU'LL NEED

DIGITAL MATERIALS

Subject photos of landscapes and objects that already have an abstract and/or patterned feel to them

TECHNICAL SKILLS

Duplicating a file

Applying the Liquify Filter

Adjusting Hue/Saturation

HARPSWELL BY THE SEA BY SUSAN TUTTLE

1 **Duplicate the file.**
Duplicate your subject photo. This will be your working file.

2 **Apply Liquify Filter.**
Push pixels around like paint on a canvas, warping your image with the Liquify Filter Warp Tool (the first tool in the Liquify Filter palette). Your efforts will begin to look like an abstract painting. Push the tool in different directions and at different points in the photo. Experiment with brush settings (size, pressure and turbulent jitter).

3 **Alter Hue/Saturation and save file.**
Alter and enhance your "painted canvas" by adjusting Hue/Saturation levels. This will yield a more painterly style. After much experimentation, my tweaks were as follows: Master: Hue: 29; Saturation: 14. Blues: Hue: -1; Saturation: -35.

Save file.

christy's tips

A fun and unique way to replicate this effect in camera is by taking a photo through bubble solution. Fill a bubble wand that is big enough to place in front of your camera lens with bubble solution. Gently hold it in front of your camera and quickly snap your photo before it pops. It can take a few tries to make this work, but the dreamy, liquefied look is well worth it.

tips · prompts · variations

∞ *After creating your abstract work of art with the Liquify Filter, try adding other filters to make your photo look even more painterly. Go to Filter> Filter Gallery and start playing!*

∞ *Add some wild, fresh abstract art to your walls—just print your finished pieces out on canvas printer paper, frame and hang!*

GUEST SPOTLIGHT: LOVELY STORY

➤ Susanna Gordon

The *Wishes* part of the title came from the childhood game my twin sister (and main subject in the artwork), Maria, and I played when we were children. We would capture the fuzzy, floating white dandelion seeds in our hands, make a wish and then release the wish into the air to be picked up by a breeze and flown off into the world. Those wishes comprise the fuzzy white collar worn by my fairylike sister in this digitally-altered artwork.

Wishes and Butterflies is made up of several original images, including a portrait of Maria, a black-and-white image of a field and scanned butterfly decorations. While the black-and-white image of the field has remained untouched, most of the individual tools found in Liquify Filter have been applied to both the portrait and to the butterflies. Throughout the project, I changed the size, density, pressure and rate of the brushes in this filter's Tool Options menu.

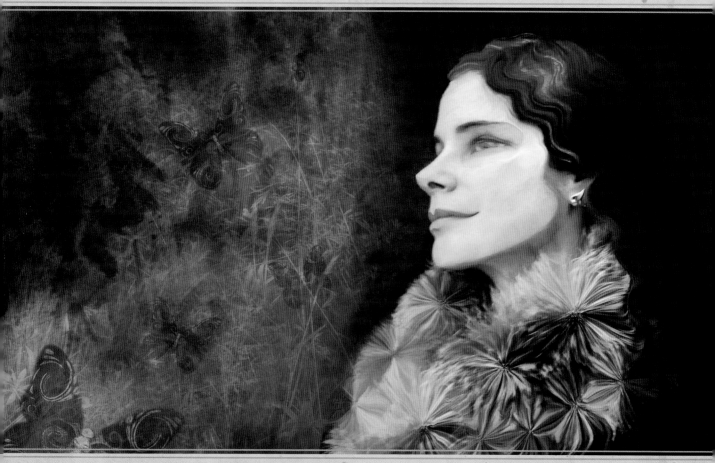

GUEST SPOTLIGHT: REPURPOSED EXPRESSIONS

> ### Michele Beschen

Turning photos into artful paintings is easy when you exercise a simple pop art-inspired back-painting technique on glass. You can choose to celebrate the process on salvaged windows or old picture frames. The glass acts as your tracing paper. My favorite subject matter is faces, but you can also play around with animals, buildings, flowers and landscapes.

Enlarge your chosen photo or portion of a photo to the scale of the glass you're working on. (Keep in mind that a larger scale with good detail and resolution leads to better results.) It can be printed on regular paper on a home printer, and I typically use a sharp black-and-white photo rather than color. Tape your photo upside down to the front side of your glass and then paint on the back side using artist acrylics. For paints, I use a titanium white and one other deep hue, and then I create a couple other values of the two for shading. Feel free to experiment with other full-color paint combinations and a more realistic paint effect, as well. You can mix in other elements by layering photographs, mirrored text, image transfers or other ephemera onto the glass to create some very unique, personalized looks. Remember, you are creating your layers front to back, so it's a good idea to take a peek at your work from the front side of the glass to make sure things are layered and positioned as you desire. A razor blade easily scrapes away any mishaps. Various adhesive mediums such as spray adhesive, acrylic gel or matte mediums, can be used to affix papers. This project is a playful way to create quirky family portrait arrangements from old photos and it's an excellent gift idea!

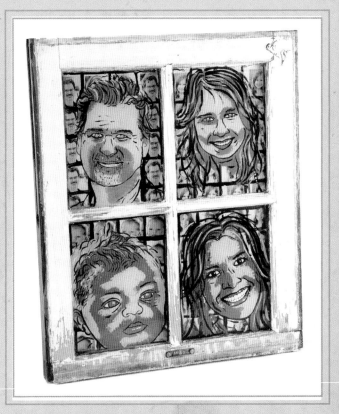

REPURPOSED EXPRESSIONS BY MICHELE BESCHEN

SWANKY BUBBLES DIPTYCH
who needs a subtitle with a project name that is so suave?

OK—admit it. How many boxes of old photos are tucked away in your closet right now? If you're anything like me, it's a number I don't necessarily want to admit. When faced with cleaning out our old photos (remember film?), we're presented with a tough choice of preserving those not-so-family-album-worthy-shots or tossing them away. (I shudder at the thought of throwing out any photographs.) So what do you do with these semi-special photos?

The happy medium lies in creating these swanky bubbles. Much like their nonswanky bubble counterparts, these spectacular spheres are sometimes reminiscent of a miniature world, but the only thing that will pop in these bubbles is the color.

I love the juxtaposition of the old photos, bold colors and posh design—and these soon-to-be treasured heirlooms are a cinch to make! You'll use a variety of circular punches to punch out the shapes, as you would paper. Pay attention to the colors and patterns as you sift through your photos and before you know it, you'll be swimming in photos that would have otherwise been relegated to a dark closet. Go on—give it a whirl!

Christy

WHAT YOU'LL NEED

Cradled wood boards (2)

Gesso

Acrylic paint–dark, medium and light colors

Glazing medium

Paintbrushes

Circular objects (old pan lid)

Old photos

Circle punches in assorted sizes

Sticky back canvas (optional)

Claudine Hellmuth Studio Matte Medium

Charcoal pencil

PanPastels (optional)

Craft knife

Blending stick

PREP

Either punch or cut out circles from photos in coordinating colors. For more texture, add in circles with photos that you printed onto sticky back canvas. Sand the backs of photos printed on glossy paper for better adhesion.

Lay out both wood boards next to one another as if they are one big canvas.

Apply gesso to your boards. Vary the pressure and use a big, rough and scruffy brush to spread it out in *X* patterns for a bit of texture. Paint the sides and then let the boards dry.

1 Apply glazing medium and paints. Push the boards together, and squirt glazing medium directly onto the boards. Squeeze the acrylic paint over both pieces in the same fashion. The darkest color should be at the bottom, the midtone shade in the middle and your lightest hue at the top.

2 Spread paints and glaze.

Working from the bottom up, begin to spread the paints and glaze by painting in an *X* pattern, as you did with the gesso. (See Prep.) Feather the colors so subtle traces of each shade are found throughout the piece. Spread the piece apart a bit and carry the painting over the sides.

3 Repeat painting and glazing.

Once the paint has dried, repeat the process, but use less glazing medium this time so that the colors are more defined and intense. Let the paint dry completely before moving on to the next step.

4 Arrange layout.

Move the boards back together. Lay out your abstract circles in a pattern you love. Creating movement and balance is the key, so think about how the eye travels (which is often left to right). Weight typically resides on the bottom, so place more circles at the bottom of the piece where the visual heaviness makes sense. Let at least a few circles overlap onto both boards.

5 Adhere the circles.

Lightly trace around your circles with a charcoal pencil to mark their locations. Brush matte medium on the backs of the circles and adhere them to the board. (If you use Sticky Back Canvas, you won't need to apply medium.) Burnish each circle firmly into place, and brush on another coat of matte medium to ensure long-lasting adhesion. It's OK for the pieces that overlap to be glued together as well; we'll separate them later.

6 Add stamping.

Dip a circle-shaped object into a thin palette of Burnt Sienna paint and stamp the lid over the top of the boards, continuing with the circle theme.

7 Tone with glazing.

Make the remaining Burnt Sienna paint more transparent by mixing glazing medium into it. Brush thin coats of the glaze onto the photo circles, and then wipe a little of it off. This toning process will make the piece more cohesive and diminish the white edges of the photo circles.

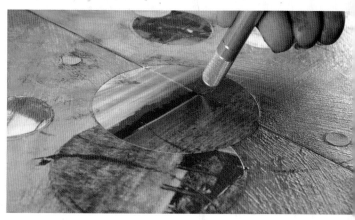

8 Tint the edges.
Using a sponge brush and the remaining glaze, tint the edges of the piece by dragging the brush along the sides. Feather the paint a bit if it seems to pool. Use the last bit of glaze along the outer sides. Allow the piece to dry.

9 Begin refining.
Carefully run a craft knife through the seam of the diptych to divide any circles that lay over the seam. Use a fine-grit sandpaper to sand the edges of the cut photos so the paper is flush and smooth with the edges of each diptych piece. Then draw additional circles with charcoal to add depth. Trace a variety of circular objects in different sizes to make drawing the circles easier.

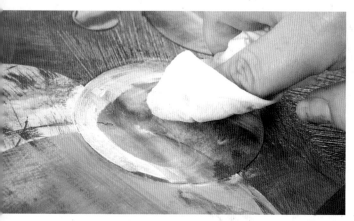

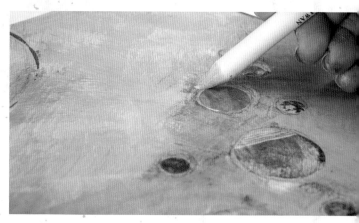

10 Highlight and feather.
Mix one part white paint with two parts glazing medium. Highlight the circles by painting arches just inside the edges. Use baby wipes to feather the paint and soften the lines. Repeat as necessary. Doing so will bring the circles forward visually. Allow the piece to dry.

11 Trace over and soften charcoal lines.
Trace all drawn circles with charcoal and use a blending stump to soften the lines into shadows. Just do the left side or the right side of each circle, whichever you choose. Try to be consistent, like you are simulating a light source.

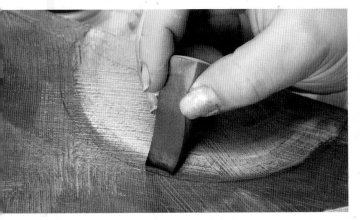

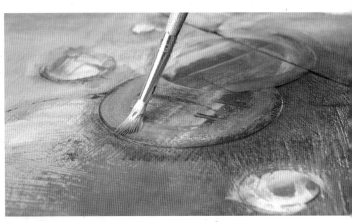

12 **Or use PanPastels.**
PanPastels can be used to create the shadows, if you prefer. Just apply with a sponge and a light touch, blending as necessary to soften. Be consistent in your placement of shadows.

13 **Add more glazing if desired.**
If you would like your finished piece to have a more painterly look, mix some of your darkest color (mine was red) with the remaining white glaze. Brush this glaze into randomly chosen circles.

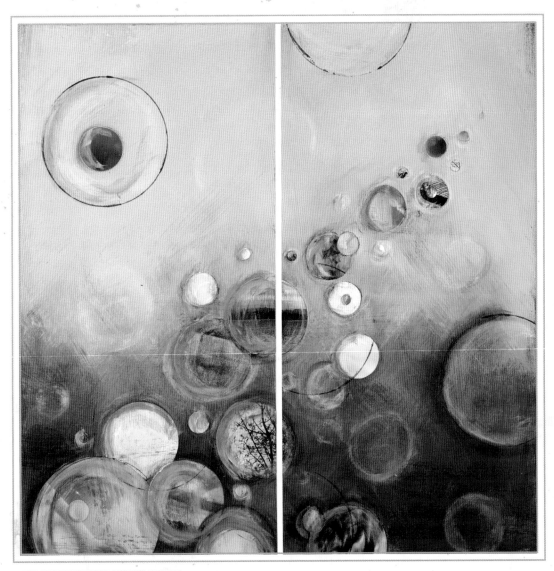

SWANKY BUBBLES BY CHRISTY HYDECK

✏ FOCAL POINT

Seemingly since the time I could walk, there has been a camera by my side. Through my school years, odd jobs, special occasions and day-to-day life, I amassed thousands upon thousands of snapshots of everything and anyone imaginable. Prints of people whose names I have long forgotten and crooked landscapes of places I once visited are among those tucked away in my closet, taking up space and regrettably collecting dust. It seems not only disrespectful, but wasteful to throw them away.

Christy

∞ Arm yourself with low tack tape and arrange photos right onto your wall. Think hearts, houses, stars, smiley faces, robots or any other whimsical design you dream up. Shoot them straight on and digitally add a frame to the photo. Print them off to use as stationery or thank you notes.

∞ Using low tack tape, adhere the photos in a border around the edge of a cradled wood board and photograph. Leave a space in the middle for a clean place to digitally insert messages, and you've just created your own, customizable e-cards.

∞ Run your old photos through a variety of paper-punch sizes and shapes. When you're done, you'll have piles upon piles of pretty patterns and colors to use in your art. Create bite-sized mini-masterpieces called "inchies," or use them to tile a background. You could also add numbers to the corners and make mini-calendars!

∞ Before using them all up, however, find a backdrop such as a table, patterned paper, blank canvas or even a scrap piece of flooring. Arrange the pieces into letters, words, phrases—any verbiage that makes your heart sing. Use a tall stool to shoot from above for a straight-on angle. These can be used as postcards or greeting cards, or you can turn them into inspiring messages by printing them on business cards and randomly giving them to strangers. What a fun way to make someone's day!

susan's tips for
taking photographs of your old photos and
arranging them in a design

Sometimes even our most treasured photographs become buried in the archives of blogs, in online storage venues and in our photo albums. I found a fun and satisfying way to keep these photographs from getting lost in the shuffle and to make a gorgeous display to boot. As Christy suggested, you can gather together some of your special photos from a particular time period or occasion, arrange them into a shape on a surface and photograph them. Or you can create a shape digitally, like I did, with a program called Shape Collage that is available for both your iPhone/iTouch and your laptop (find it at www.shapecollage.com). This heart layout was created on my laptop with Shape Collage's Pro Version (there is a free version and a Pro Version). The Pro Version does not display the company's watermark on your work and allows you to save your generated photo shape as a PSD file, which you can further manipulate in Photoshop. The finished product can be displayed in a variety of ways:

∞ as a print

∞ on canvas (I am a fan of Easy Canvas Prints at www.easycanvasprints.com)

∞ as a holiday or special occasion card

EVERYDAY LOVE BY SUSAN TUTTLE

CONTRIBUTORS

Pam Carriker

Samantha Kira Harding

Misty Mawn

Claudine Hellmuth

Pam Carriker teaches internationally as well as nationwide and is the author of the best-selling book *Art at the Speed of Life*. Her articles and artwork can be found in more than thirty publications including *Somerset Studio, The Stampers' Sampler, Art Journaling, Somerset Apprentice, Where Women Create, Artful Blogging, Cloth Paper Scissors* and *Studios*. Pam serves as a Director's Circle Artist for Stampington & Company, has also created instructional videos for Strathmore Artist Papers line of Visual Journals and various lines of rubber art stamps, and is currently developing a line of products with Matisse Derivan.
pamcarriker.com

Samantha Kira Harding is a mixed-media and journal artist hailing from Arizona. She's written for several publications, including *Somerset Studio* and *Cloth, Paper, Scissors*, and teaches creativity and journaling techniques. A self-taught artist, Samantha strives to show others the creativity they have inside of them.
www.journalgirl.com

Misty Mawn is a full-time artist, mother and workshop instructor. She spends every day possible creating, playing, exploring, learning and constantly being inspired and intrigued by everything around her. Her passion to create continues to bless her life with purposeful work and fulfilling adventures. When not in the studio, she can be found amusing and being amused by her two darling children, cooking up some creative concoction in the kitchen or strolling the back trails with her beloved camera in hand. She is the author and photographer of *Unfurling, A Mixed-Media Workshop*.
mistymawn.typepad.com

Claudine Hellmuth is a nationally recognized collage artist, author and illustrator. She combines photos, paint, paper and pen into quirky, whimsical retro collages. Her artworks have been featured on *The Martha Stewart Show*, HGTV's *I Want That!* and the DIY Network's *Craft Lab*; as well as in *Mary Engelbreit's Home Companion* magazine and *The New York Times*. In addition to creating her artwork full-time, Claudine has developed a product line with Ranger Inc., under the brand name Claudine Hellmuth Studio. Claudine licenses her illustrations to gift and craft markets and teaches collage workshops in the United States and Canada. She has written three books and produced three DVDs about her techniques. Originally from Orlando, Florida, Claudine now lives in Washington, DC, with her husband Paul and their very spoiled pets, cats Mabel and Brian and dog Maggie.
www.collageartist.com

Linda Plaisted

Madelyn Mulvaney

Susanna Gordon

Pilar Isabel Pollock

Michele Beschen

Linda Plaisted is an award-winning, classically trained American painter, photographer and mixed-media artist and has exhibited her work in galleries and museums around the world. She is a pioneer in the art of contemporary photomontage illustration. Each piece of artwork she creates is layered with images she has captured in her original photography, drawings, paintings and collected ephemera to create narrative mixed-media pieces with subtle depth and dreamlike detail. Linda's work has been featured in books and magazines and on *Design*Sponge* and *DailyCandy* and can be found in corporate and private collections worldwide.
www.lindaplaisted.com

Madelyn Mulvaney is a writer and photographer and is creator of the 'persisting stars' photography e-courses. She lives in a house by the sea with her daughter Tess, son Noah and a dog named Roxy. Madelyn is currently writing her first book, *The Art of Living Cheerfully*. She is passionate about morning coffee, Polaroids, vinyl records, swing dancing and long road trips.
www.madelynmulvaney.com

Susanna Gordon is an artist, photographer and blogger living in New Jersey. Her artwork has been published in numerous publications.
www.susannassketchbook. typepad.com

Pilar Isabel Pollock is an artist and writer who lives in Southern California. As an artist, Pilar explores the world of mixed media through her use of different art forms, often merging two or more mediums in a single piece to create a delicious fusion of texture and depth. As a writer, her work examines the psychological and spiritual elements of the artistic process. Pilar's work has been published in several publications, including *Stampington's Digital Studio*, *Pasticcio Quartz*, *Kaleidoscope* and *In This Garden*. She is a contributor to *Digital Expressions* by Susan Tuttle.
www.pipnotes.typepad.com

Michele Beschen Fearless repurposing reinvigorates the conscientious can-do spirit in us all and Michele has made it her life's work to share this philosophy through refreshing ideas, stories and approachable DIY projects. She is the host and creator of programs such as *B. Original* on the DIY Network and HGTV, and her newest series *B. Organic,* appearing on PBS and Create TV. She has been a guest on *The Nate Berkus Show*, *The Rachael Ray Show* and *Good Morning America*. Her enthusiastic, real-life approach to creative living is also featured regularly in *Do It Yourself Magazine*, her signature *Courage to Create* DVD collections and other media outlets. Michele calls Madison County, Iowa, home, and she shares home with her husband Jon and daughters Madeline and Berkley.
www.couragetocreate.com

ABOUT THE AUTHORS

Susan Tuttle

> Susan is the author of two previous North Light books, *Digital Expressions: Creating Digital Art with Adobe Photoshop Elements* and *Exhibition 36: Mixed-Media Demonstrations and Explorations*. She is a photographer and an online digital art and photography instructor who resides in a small, rural town in the state of Maine with her husband and two children. In addition to authoring her own books, Susan is a contributor in various North Light publications, including Jenny Doh's *Art Saves* and Liz Lamoreux's *Inner Excavation*. Her work has appeared in numerous issues of Stampington & Company publications, including *Somerset Studio*. Visit Susan's website, SusanTuttlePhotography.com, to learn more about Susan and her art and for great tips and advice on photography and more.

PHOTO BY CARL NETHERCUTT

Christy Hydeck

➤ Never leaving home without a camera by her side, artist and photographer Christy Hydeck takes delight in life's simple pleasures and immerses her world in all things artistic. Christy lives with bipolar disorder and Tourette's syndrome and credits her sense of stability to the huge role that creativity plays in her life. Driven by a need to experiment and play, Christy is also an avid collector of words, a believer in miracles and a lover of both nature and animals. She also has a special place in her heart for terribly bad puns and wordy run-on sentences. Christy is committed to sharing her vision for finding the extraordinary in the ordinary through blogging, writing and her laid-back style of personal instruction. Visit her websites for a complete list of publications she has been featured in or simply for a dose of inspiration: AlwaysChrysti.com and ChristyHydeck.com.

RESOURCES

CHRISTY'S:

FOR A COMPLETE AND ALWAYS-EVOLVING LIST OF THE PRODUCTS, BRANDS AND MATERIALS I USE MOST OFTEN, PLEASE VISIT THE FOLLOWING PAGES ON MY WEBSITE:

- ∞ Photography Gear: alwayschrysti.com/photography-gear/
- ∞ Mixed Media Supplies: alwayschrysti.com/art-supplies/
- ∞ Phoneography Gear: alwayschrysti.com/iphonography-gear/

MIXED-MEDIA SUPPLIES:

- ∞ Claudine Hellmuth Studio Paints, Mediums and Brushes: rangerink.com
- ∞ Pam Carriker's Sketching Ink and Mixed-Media Adhesive, pamcarriker.com/products/pam-carriker-liquid-pencil-sketching-ink
- ∞ Pan Pastels & Soffit Tools: www.panpastel.com
- ∞ Tim Holtz© Adirondack© inks: rangerink.com
- ∞ Yes! Paste: www.ganebrothers.com/products/adhesives/yespaste.html
- ∞ Dremel: www.dremel.com
- ∞ Grafix Original Incredible Nib: www.grafixarts.com
- ∞ Diamond Glaze: www.diamondglaze.com
- ∞ Rubber Stamps used on pages 92–93 and page 100 is from Inkadinkado: www.eksuccessbrands.com/inkadinkado

PHOTOGRAPHY AND PRINTING RESOURCES:

- ∞ Lensbaby: lensbaby.com
- ∞ PostalPix: www.postalpix.com
- ∞ The Impossible Project (Polaroid film): the-impossible-project.com
- ∞ Claudine Hellmuth Studio Sticky Back Canvas: rangerink.com
- ∞ Olloclip iPhone lens: www.olloclip.com

SUSAN'S:

PHOTO-EDITING PROGRAMS AND TOOLS:

- ∞ Adobe Photoshop Elements and Adobe Photoshop Creative Suite: www.adobe.com
- ∞ Wacom Intuos Graphics Tablet and Pen: www.wacom.com

TEXTURES:

- ∞ www.textureking.com
- ∞ Flickr Sharing Groups: www.nicholev.com www.textureonline.com www.mayang.com/textures www.thecoffeeshopblog.com www.inobscuro.com/textures www.florabellacollection.blogspot.com www.texturevault.net

PHOTOSHOP BRUSHES:

- ∞ www.brushking.eu,
- ∞ www.obsidiandawn.com,
- ∞ www.deviantart.com
- ∞ www.photoshopbrushes.com/brushes.htm,
- ∞ www.damnedinblack.net/brushes.htm,
- ∞ www.annikavonholdt.com/brushes,
- ∞ www.missm.paperlilies.com/01_brushes.html,
- ∞ www.brusheezy.com/brushes
- ∞ www.myphotoshopbrushes.com,
- ∞ www.inobscuro.com/brushes

FILTERS:

- ∞ www.cybia.co.uk/theworks

FUN PHOTO-EDITING LINKS:

- ∞ www.poladroid.net
- ∞ www.shapecollage.com (also available as an app for iPhone/iTouch

DIGITAL SCRAPBOOKING SUPPLIES:

- ∞ www.cottagearts.net

WRITING/JOURNALING RESOURCES:

- ∞ www.creativitygames.net/random-word-generator
- ∞ www.writingprompts.org

PRINTING RESOURCES:

- ∞ www.adoramapix.com
- ∞ www.easycanvasprints.com
- ∞ www.canvasondemand.com

SUSAN'S PHOTOGRAPHY AND PHOTO-EDITING GEAR:

- ∞ www.susantuttlephotography.com

ONLINE RESOURCES/DIGITAL APPS

YOU CAN MANIPULATE YOUR IMAGES WITH A VARIETY OF APPS FOR IPHONE AND IPOD TOUCH. HERE ARE SOME OF OUR FAVORITES:

Mosaiq
Noir Photo

SOCIAL SHARING
Instagram
Photofon
TaDaa

STORYBOARDS
Diptic
Montage
Photo Mess
PhotoShake

A PHOTO A DAY
Photo 365
Project 365

PAINTING TECHNIQUES
AutoPainter
Corel's Paint It! Now
Inspire
Iris
Photo fx
Photo Studio

DOF FILTERS
Camera+
FocalLab.
Instagram
QuikDoF
TiltShiftGen

LENS FLARE
lensflare
Lenslight

SELECTIVE COLOR
ColorSplash

TEXTURE
100 Cameras in 1
Backgroundz
Bad Camera
FilterMania

Grungetastic
Iris
PhotoForge
Pic Grunger
PicFX
Pixlromantic
ScratchCam
Snapseed

VINTAGE
Infinicam
Lo-Mob
PhotoStudio
Phototreats
Skip Bleach
SwankoLab

WATERCOLOR FILTER
Artista Haiku

POLAROIDS
ClassicINSTA
FotoRoid
Lo-Mob
Polarize
Polaroid Digital Camera App
ShakeItPhoto

CROSS PROCESSED EFFECT
iDarkroom
Camera+
Cross Process
Magic Hour
PhotoWizard
PictureShow

BLUR
Art of Blur
Blur FX
FocalLab
SlowShutter

VIGNETTING
Blur FX
CameraBag

FocalLab
FX Photo Studio
iDarkroom
Magic Hour
Noir Photo
Picture Show
TiltShiftGen

NOTE: THESE APPS WORK WITH THE IPHONE4 AND IPOD TOUCH FOURTH GENERATION AND MAY OR MAY NOT WORK WITH CURRENT/FUTURE VERSIONS OF THESE PRODUCTS.

You can find all of our extras (including downloads and links to many of the resources on this page) at www.createmixedmedia.com/photo-craft.

INDEX

acknowledgments

SUSAN TUTTLE

Susan would like to thank the following people for making this book possible:

Tonia Davenport and the North Light team for believing in the concept of this book and for giving Christy and me the wonderful opportunity to share it with an audience.

Bethany Anderson and Kristy Conlin, our magnificent editors, for their hard work and creative thinking that has helped shape and execute this book.

All of the people at North Light who have made the production of this book possible. You are all so very talented.

Christy, my talented co-author. It has been an exciting adventure and pleasure to work with you all of these months on something we both cherish, value and wish to share with others.

Our contributors for their stellar contributions that have enhanced many of the projects.

I would also like to thank you, the reader, for joining us here. I hope you will find the book to be enjoyable and of value.

CHRISTY HYDECK

There are, without fail, at least a bazillion and one people who have helped shape and influence who I am, the work I do, and the woman I continue to become. However, my editor tells me that there is not enough space for me to properly thank them all. As someone who spent a big part of her life feeling excluded and often overlooked, it didn't settle well with me to list some people and not others. I believe that each person's contributions has significant value, and one isn't more important than the other. In the end, I decided to break the mold and publish the complete list of my acknowledgements on my website, which you can find here: http://alwayschrysti.com/photo-craft/.

However, I did want to take the space to sincerely thank my gifted co-author—this book wouldn't be in your hands without her. Susan, I will always be so thankful that you enthusiastically jumped on board this crazy idea of mine. You helped me transform it from a rough idea into a tangible reality. I have *genuinely* enjoyed this journey with you, both personally and professionally. I will always treasure the late-night giggles, how naturally the book unfolded and the countless memories made during the process. I am ever so grateful that I have grown so much as a result of our joint experience and simply knowing you. You rock.

ISBN 978-1-4403-1870-2

Other fine North Light Books are available from your favorite bookstore, art supply store or online supplier. Visit our website at www.fwmedia.com.

16 15 14 13 12 5 4 3 2 1

DISTRIBUTED IN CANADA BY FRASER DIRECT
100 Armstrong Avenue
Georgetown, ON, Canada L7G 5S4
Tel: (905) 877-4411

www.fwmedia.com

DISTRIBUTED IN THE U.K. AND EUROPE
BY F&W MEDIA INTERNATIONAL, LTD
Brunel House, Forde Close, Newton Abbot, TQ12 4PU, UK
Tel: (+44) 1626 323200, Fax: (+44) 1626 323319
Email: enquiries@fwmedia.com

DISTRIBUTED IN AUSTRALIA BY CAPRICORN LINK
P.O. Box 704, S. Windsor NSW, 2756 Australia
Tel: (02) 4577-3555

EDITED BY BETHANY ANDERSON AND KRISTY CONLIN

DESIGNED BY KELLY O'DELL

PRODUCTION COORDINATED BY GREG NOCK

metric conversion chart

TO CONVERT	TO	MULTIPLY BY
Inches	Centimeters	2.54
Centimeters	Inches	0.4
Feet	Centimeters	30.5
Centimeters	Feet	0.03
Yards	Meters	0.9
Meters	Yards	1.1

SNAP, CLICK, CREATE!

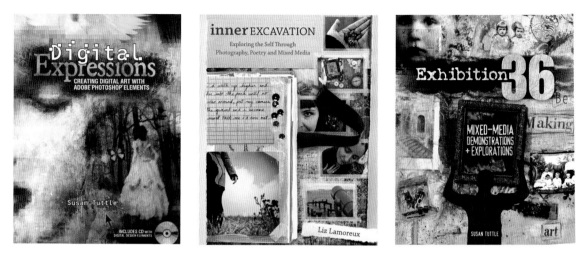

CHECK OUT THESE NORTH LIGHT PRODUCTS!

THESE AND OTHER FINE NORTH LIGHT PRODUCTS ARE AVAILABLE FROM YOUR FAVORITE ART AND CRAFT RETAILER, BOOKSTORE OR ONLINE SUPPLIER. VISIT OUR WEBSITE, **WWW.CREATEMIXEDMEDIA.COM**, FOR MORE INFORMATION.

7/8/13

> **A GREAT COMMUNITY TO INSPIRE YOU EVERY DAY!**

∞ CONNECT WITH YOUR FAVORIT MIXED-MEDIA ARTISTS

∞ GET THE LATEST IN JOURNALIN COLLAGE AND MIXED-MEDIA INSTRUCTION, TIPS, TECHNIQU AND INFORMATION

∞ BE THE FIRST TO GET SPECIAL ON THE PRODUCTS YOU NEED TO IMPROVE YOUR MIXED-ME CREATIONS

 FOLLOW CREATEMIXEDME LATEST NEWS, FREE WAL AND CHANCES TO WIN FF

SEARCH

NBOX,
TTER.